# The
# Indian
# Righteousness

# The Indian Righteousness

### Theoretical Patterns of Conflicts in Present Indian Life

Amulya K. Mohanty

PARTRIDGE

**To order additional copies of this book, contact**
Partridge India
000 800 10062 62
orders.india@partridgepublishing.com

www.partridgepublishing.com/india

*To*

*Sudhir Kakar,*

*the great scholar of Indian mind*

# Contents

*The Order in Indian Chaos:*
*A personal sketch*

# The Order in Indian Chaos:
# A personal sketch

I have an impulsiveness to theorize the large radius of worldly existence. It is my pleasant, wishful movement. But discovering and theorizing the patterns in deciding right and wrong, justice and injustice in current Indian life have been a difficult exercise in spite of some clear features of Indian society. Nirad Chaudhury called India a Circe for the confusing, chameleon character. From questions in my immediate existence, the contemporary psyche of my own Odia people who are not beyond the structure and superstructure of Indian character, was the first social question in my mind; and therefore understanding the Indian mind was the beginning of my intellectual pursuit. I found myself very sensitive to a provocatively lost self in my surroundings, to a people not carrying a sense of history and who are not awake to many meaninglessness, irrationality in their subconscious. I became serious on definitions of ethics followed in post-independent Indian society like the Emperor Ashok who was obsessed with the question of righteousness.

The Indian Righteousness is my theoretical and emotional expose that the definitions of righteousness followed in Indian society in post- independent and post-liberalisation times in family and public life do not address their historical backgrounds and how some new developments lack theoretical nourishment. Further, the context- sensitive way of deciding right and wrong which is the broad tone of Indian ethics, is not certainly adequate to explain many a behaviour of righteousness in present times and I am intensely baffled by the Circe of behaviour in public life, in mathematics of society and taking positions. The prose therefore seeks *theoretical enrichment* on many unfortunate interpretations of righteousness, which also have been part of my Indian life. Equally I am anxious for a position of praxis, by changing thought patterns for a better position of righteousness in society that I desire and which I have boldly attempted in the book with my patterns and doctrines. I can see a theoretical anarchy in political-social doctrines in present Indian society that does not go very well for advancing a democratic culture and I intend to encourage new doctrines for such cultural conflicts in Indian rationality. I had to retrace my steps on time and discover my personality from the deposits of history in my existence so that I will be able to understand my surroundings in its true colour. This is my intellectual revenge on unrighteousness.

So many dialogues for strengthening democracy, a curiosity that I see in Indian public life, should learn

from the patterns of changes in history. History is both an idea and material situation. Society has changed by responding to new thoughts and by changing structures or situations. Indian society in my theoretical observations is also very much an Idea or a Thought, for significant influence of world view and colonial impressions, for stress on idealism and many idealistic interpretations of existence, even though helplessness for situational and structural limitations is very much evident in present Indian society. But life by its nature is both an idea and a situation, dependant on both, both having limitations affected mutually. Any strategy of change therefore should target both the aspects of mind and matter in their logical perspective depending on which is the first cause in a particular problem.

Last two hundred years of our history have not only put intense impact on Indian thinking patterns but also this has created disturbances in the interpretation of Indian history and culture . And we are the collective unconscious of such 'propaganda of interpretations' that is very questionable now for historians and rational thinkers. The modern Indians who enjoy the benefits science also demean it and worship faith and god men. People do not see hope much in social mechanisms as much as in internal tuning, self-correctedness and mystic faiths. While the definition of self-correctedness may be debatable in a democratic society as distinct from a tradition and religious bound life, by such beliefs Indians lose enthusiasm for social corrections

and mechanisms. The disturbed progress in Indian rationality today is the story of a long philosophical battle that is continuing till present times– the battle between materialists and idealists, between internal tuning and social mechanisms. It does appears in cruelty a spiritual fashion of some idealists either in helplessness and so compromising under the banner of ideological colour and arrogance of their doctrines of questionable cause and effect. But then the Indian psyche caries its age old convictions on anxiety of human existence and some good sense of it will continue for long.

My book may create excitements but not without a moral evolution that I desire to contribute to changing further the Indian thinking from a lost mind to a rational mind that is yet to be a wide phenomenon. I imagined that I should stretch myself to all possible sides like Nirad Chaudhury to understand India, like the dream grand unified theory in physics, without which it is difficult to understand the chameleon character, the width of culture and the length of Indian history. These have been through powerful works of Sudhir Kakar, Nirad Chaudhury, Romila Thaper and others. When I was writing the present work, I came across sociologist Dipankar Gupta's book *Revolution from Above* calling for citizen-elite intervention in society for solution to many discontents in Indian democracy. I am passionate now to take a stand so, based on proofs of history and given my theoretical view of social responsibility of common Indians.

The obsession of righteousness once took me like a flight to the location of good and bad in universe, in philosophic and inconclusive quantum physics and what it may speak on values to follow in life. I fell in love with quantum physics in my 40s and felt that I should have read physics. This is for my obsession with locating the reality and any meaning it may indicate in existence. All along educated in social sciences, my time is over to read physics without a university, but for the curiosity, I read many interpretive essays on science, of physicists like Richard Feynman, Victor stinger, John Polkinghorne, Stephen Hawking, Amit Goswami, Fritz Schafer and Fritjof Capra. Their writings exposed me to interpretations of reality and impacted me deeply at fundamental levels of thinking and helped further the progress of my reasoning sense. The understanding of scientism against the journey of philosophy and religion, their interpretations on matter, consciousness and values helped me to understand modernism and trans-modernism, the pursuit of transcendence and society mathematics in Indian life. I understand that society is both fragmented and interrelated, both quantum and Newtonian. A strategy for change may focus on local symptoms for immediate correction but the problem again comes out so long as a network wherein the first cause is not properly addressed, but some problems are fragmented in their own sphere and should be treated like that.

The prose has taken birth from my intense pursuit of originality and theoretical impulsiveness and in that long solitary pursuit Puspa, my wife has given great care for my intellectual indulgence. While intellectuality is my one passion, it is her ambitious wish for the success of a husband. She carries faith and reason and I a lot of reason and it has been at times an interesting dialogue on the significance of faith as against efficacy of social mechanisms on many problems of life. In the beginning of my married life in 30s I was intensely social in my thinking, in search of patterns of larger social existence. She took responsibility of the family, the house inside so efficiently and now I feel very thankful and obliged for her care given to pursue my passions. I was feeling unhappy, sad by looking around the blocked Renaissance and the modernity, which has been difficult for Indians than the easy westernization. The thoughts interfered with my parallel obligations so much that I attempted to stop thinking about society, about politics and to get into a life of self-indulgence, be happy enjoying the nice, successful things around. But this has been difficult, unsustainable. Like the root left under the soil, the impulsive thinking comes out every time when I try to forget it. Perhaps this is the meaning of my existence. But I have very well learned to feel happy, looking at success around while living intellectually and critically, a development that has been possible partly by frequent intervention of my wife. It was a discovery that I feel compulsive to be a

writer who is keen on discovering *theoretical orders* in meanings around, in rationality. To discover meanings is the meaning of my existence and to live by it, the ultimate pleasure of my life.

This book though intensely theoretical, takes too a position of moral praxis. It is my expression of some elegant patterns and doctrines and by locating and expressing this, I feel ultimately a mellow down in the anxiety of my intellectual existence.

# Chapter 1

*The Indian is adept in family matters, poor in social mathematics. But India is a material beauty now.*

## Nirad, Naipaul, Sudhir and Myself

In my thirties I was very uncomfortable in my Indianness. That I am a diagonal line on society, in a mood of confrontation. I was not romantic on society like the nationalists. I was not in a mind to escape either. The definition of rationality in my existence around was the subject of my anxiety. The lost minds provoked me; and I was very much fit for an intellectual revenge. I searched the mathematical patters of my surroundings; the society was a bigger question than the pleasure of personal indulgence; and understanding the Indian mind became as a consequence the beginning of my intellectual pursuit.

The first part of my life– the definition, the beliefs belonged to my parents, to my society and my life in

government service. All along I experienced a split in my existence; a war between logic and compulsions, democracy and traditions, law and other jurisprudence. So it appeared to me that the character of Indian society is a split one, a lost mind that fails to see itself, that feels heavy to rise by the deposits of history. The two splits in me did not conform to each other; I revolted to end the splits and be in the mode of conviction. The writings of Naipaul, Nirad, Sudhir Kakar reconditioned me theoretically and I got a sanction to my convictions. I did not felt threatened by the regressive impressions any longer, because the impression was false by significance, a dream rather, a false colonial identity in my surroundings, an identity that has to be defeated in mind only. It has no base to hold, so it does not require much sanction of the society; many Indians are not able to do it because they find an imaginary basis and accept it to be just.

It was my revenge that I became aggressive to think theoretically. I had to proceed almost alone by inspiration from books, for I was surrounded very much by lost self hardly with any originality and convictions. In every landscape of Indianness, the rationality of Indian conduct was my point of observation. There was no question of divine merger between observer and observed; subject and object did not coalesce for I refused to be a part of the lost process; so it deprived me the pleasure of observation; and I became a witness to things around. There was little in the self-glorifying,

Split Indian Character
experiencing conflict
between democracy &
Other mind, in shadows
of history.

uncritical nationalistic interpretation as a methodology to access the post-independent patterns of righteousness. The perspective is rather arrogant tied to archaic fixations and spells of history that derailed the Indian self. As we have in Odisha state, some obsession for the past glory of Kalinga kingdom, which some political stalwarts aired to regain the lost glories.

A quote in Sanskrit says:

*Barsana Bharat sresta, desanam Utkal sruta Utkalasya samodesa desa nasti mahitale.*

Among countries India is the best
In India Utkal is very much heard
There is no parallel to Utkal (present Odisha)
On this earth.

It also means if the world is a tank, India is a lotus in it and then the filament of lotus is Odisha. Many quote as a part of self-glorification of their culture and land. I find in them a satisfaction by accepting the past glories and being profane on the present; their slipping into the past gives security of emotions against the anguish in post-colonial Indian society. But for me it was insular, I found little substance around. So I choose the critical line of thought in history; and the writings of Sudhir Kakar, Nirad Chaudhury and others enriched my theoretical understandings on Indian mind and character.

Nirad Chaudhury was the first very original interpreter of Indian character in colonial and post-colonial times. With his innovative discoveries of forces in history and geography, Nirad razed on Indian character, as an anguish Indophile oozing painful feelings. *A prose so wide in cultural landscape, with elegant patterns, intellectually doctrinal and courageously impulsive in generalisations, he is perhaps the only literary giant in post-independent India much debated, analyzed and much remembered.* Probably many have developed an obsession in loving his writings as me. While Sudhir Kakar has laid bare the psyche behind Indian character, Nirad has shown the location, the first cause of characters in cultural-historical landscape.

V.S Naipaul, in a prose of pathos, in intuitive style, has discovered the lost Indian society that is incapable of assessing itself. It hardly puts questions because it has all answers in its traditions, religions and myths; it prefers to follow what others have said instead of taking a stand of its own and rolls in infantile regression in its colonial identity. Not so impulsive or doctrinal like Nirad, Naipaul has discovered India as a nation with wounded culture and features of darkness.

Once I went to office after reading some prose of Naipaul in his *Literary Occasions*. After a while, a person came to my office and expressed his resentment towards me badly for some misunderstanding on his part that was discovered after some minutes. And he swiftly went away the moment he came to know that

I made no mistake. But I could not react boldly to his manner during the process, because I was feeling very placid; and I discovered that the fire, my usual intellectual aggressiveness had become rather inactive. I had just finished reading Naipaul; it was a strong mellow, a prose so beautiful in his honest feelings and intuitive revelations; so slow with pauses that zeroed the speed in my mind and body. I felt a silence around, in myself, a breathing so slow and long as if I was moving in a tranquil landscape in transcendental. Such was the impact of Naipaul on my aggressiveness.

Sudhir Kakar as a psychoanalyst is reliable without emotional appeal and careful about statements. He is a very important writer, a powerful intellectual who has made many things so clear about us– Indian family, sexuality, religion, mysticism, the illogical ego of Indian in daily conduct– *that to read him is to transcend the lost Indian self, which I have personally experienced.* Anybody who has not read him or similar writings has missed authentic portrait and awakening on Indian psyche, culture and character in post- independent times. To miss him is to remain lost and to read him is to recover from many obsessive impressions of history in our thinking.

What has happened to the wise, non- controversial messages in literary charms of Naipaul and Nirad? I have a feeling that this has not so percolated through Indian English readers and intellectuals because of some new barriers. But I confidently applied the generalizations:

the Hindu view of life and the post-colonial lost self are the two major theories like the theory of everything to explain life in present Indian society. I very much refused to be a lost part of the process, so I became an observer as an intense witness to the goings around.

## A theorising literature

Literature is not like a scientific line of statement, nor it should disregard empirical truth. Literary writings flaunt, use decorative about dominant feelings on issues of life, and create feelings of self-perception. Literature draws a statement to discover patters, may not be accurate and may be impulsive to create moods of excitements so that people will give their hearts to the seriousness of the writer and his writings. Then only new patterns of thinking become possible in society. But giving justice to a writer should not move in literary style. It happened so in case of the great known Indian Nirad who theorised many Indian obsessions into elegant expressions like 'the Hindu virtues like its vices are products of feebleness'. His first was book published in 1951; it was a time of acutely lost self and therefore surely difficult to accept him who dedicated his *Autobiography of an Unknown Indian* to the British Empire. But an author who fails to demystify himself and the reader, who is certainly less responsible, interprets with errors of misunderstanding.

*This happened to him who had some failed precision in his writings, in my observations.*

But I have a convincing intensity of doubt that the dedication in the *Autobiography to* the British Empire, the way he expressed it directly, was a mock-rhetoric that was told later when Nirad was much criticized. Knowing the person in some detail through his varied writings, a mischievous element appears in my perception. Though critical of British malice, servility and lack of originality in political life after independence, he lost himself somewhere in a mist clinging to either of identities. He was certainly not proud of Indian civilization the way he denigrated its philosophy, baleful geography, character of people that Indians are Europeans corrupted in tropical climate and only salvation lies in retreat to its identity, are the terrible discontents in his personality. But Nirad could not be unidirectional in the doubtful European salvation of Indianans; and he was not able to lose himself in the British identity like wearing and sleeping in a *dhoti* in England.

His discontent of an extreme type was from his loyalty to British values, civilization whose decadence he also criticized, but that was also the inner portrait of great leaders starting from Indian renaissance to Nehru, quite vocal and felt blessed to an extent and who carried hopes and followed different models to revive the Indian identity in scientific humanism of Europe with the help of British rule. India adopted the similar

patterns with some originality of socialistic humanism by Nehru who was but more British and less Indian. Second, though he wrote that the British conferred subject hood on Indians but withheld citizenship, he very much discarded the imperialistic impact on colonized Indian situations and its materialistic interpretations that derailed the Indian self in helpless manner. It was another major flaw in his literature and a proof of his British loyalty. *Nirad was a literary extremist in that direction.*

The theoretical structure of his generalisations was a strong negativity in Indian self, so much so he razed on Indian character to the extent of being hopeless anthropologically on a continent making anybody corrupt who comes to India; into inertia and squalor by the formidable geography and Hindu view of life and he sees only hope in the Aryan discovering his European identity. But then watching the quality of post-independent politics, the discontents in our democracy, the intellectual ineffectiveness, servility and peoples' character in inertia of rationality, the way the middle has become quickly western in Indian inferiority and hesitantly modern in justice, liberty, equality and rationality considerations, *it takes me at times to the baleful Indian landscape of Chaudhury.* Like the colour complexity of Indian girls feeding a vast fairness industry. Also executives and leaders in India preferably wear white shirt. Why not blue? I do not like white colour. I did not have a white shirt for a

long time. Whether colour has anything to do with honesty and efficiency? In white I find many too gentle to inspire the team and to be on the spot. I do not have objection for white. It may be proper for hot climate of India. I have only objection on the obsession for white colour and the adjectives associate with white from British colour complexity. Nirad has vividly portrayed in Autobiography how marriage was difficult for black girls in Calcutta and there were many scandals for the colour.

He was the first serious Indian critic of anything Indian without slightly being narcissistic. His raze on Indian character for its decadence, first by Islamic spell and second by British subjection, possessed him to the extent of being very critical of things Indian. But he was rightly worried by anglicized Indians' British servitude, arrogance, lack of originality and intellectual alienation in own land. Like physics searching for the last cause of universe, he went to an amazing depth to understand the Hindu character, at times in intuitive impulsiveness and initiated a trend of very critical intellectuality with his thesis of geography and history that put him in a debatable status by anybody who failed to read him between the lines.

Many his messages I find highly useful to understand the times today. 'Long live the British rule' was his satiric comment on mindless colonial legacy in Indian thinking and character, the continuation of a servile mind and arrogance of anglicised upper class

Indians towards natives, so much so, he uttered that all in ICS should have been hanged on 15th august 1947, who were the carriers of British style of ruling and Indian inferiority.

An eternal character that denies to die out, some viciousness so innate, immovable that I often feel helpless, am forced to conclude like a mystic, a reason so imaginative, transcendental to our reason and ability, when I discover that the doctrines of Indian psyche continue to play with innovativeness till present times. Looking around gives me anguish and lost minds of a different type that is highly reluctant to further democracy, at times retreating to intolerance and irrationality. The democratic jurisprudence of Indian constitution is also reluctantly acceptable to Indian psyche, clinging to hierarchical nature of practices in relationships basing on rank, wealth, profession and poor appreciation of independent thinking. These have been the facts in public life.

## *The locus of righteousness*

The methodology of Nirad Chaudhury was heavily based on cultural, anthropological locus as the effective cause of Indian character, which does not give justice to situations in a colonial rule and economic imperialism. But the cultural- philosophical view irrespective of time in history remains as a dominant force in analysis on India. Like the incredible romance of mysticism in

Indian obsessions; myriad ideas in temples, rituals, philosophies, songs and dances glorify a connection with deep, inexplicable feelings of life– a pressure of transcendence to cross the finitude of one's existence. Italian Odishi dancer Ileana Citaristi beautifully glorifies the transcendence as a desire of life when she says:

'I was in search of a land where I could express in a total and unrestricted way those inner questions of the soul that could not find satisfaction in any of the solutions offered by the present patterns of living of this western civilization. After completing my doctorate in philosophy in my own country, Italy, I followed the callings of ancestral and inexplicable paths and reached this land of Odisha. Here, completely dedicated to the sacred art of Indian dance ......I am able to give shape to the inner striving of the soul and overcome the anxiety of human existence.'

Indians' search for the truth of life is unquestionably deep in history and its innate spiritual culture has plenitude of thoughts of living life beyond reality and limited social existence. Society is not the only concern when individual is connected with the vast universal existence and this call of transcendental infinitude has intensely defined our living, our righteousness in its variegated interpretations.

But the colour of culture has a painful side too. Life in Indian situations often meets the death of romance; and it is the presence of transcendental opportunities that helps to mellow down the social sufferings at least psychologically. That is why the post-independent India has been a painful impression for many writers on the reality of life. The famous Odia story writer Manoj Das tells such an impression that I read in a newspaper: One European lady, about fifteen years ago came to India to understand the country like many occidentals' obsession for the oriental. On reaching Delhi, she immediately rushed to Varanasi. Next morning she entered the Ganga river to take the holy bath that is believed to make one pure from the impressions of evils deeds. Suddenly she felt as if somebody is touching her, rather trying to hold her. As she turned back she shouted in fear– fingers of one half-burnt dead body thrown after cremation were giving the impression of the mystical India and dirty external world. She left Varanasi immediately and left India.

*But I must say that India is a material beauty now.* From finitude to infinitude, the liberty economics after 1991 has unleashed the romance of matter in public life, through hopes, innovation and fancies and is wonderful at least by service delivery to customers by the private corporate. The IT sector in Bangalore has successfully created lakhs of jobs; the Phoenix shopping mall there is like a heaven height of fantasy, the modern temples

of middle class indulgence, created by invisible hands of private sector; and the liberalization has taught how to create logical, scientific, democratic management in work place for smart delivery of services to customers. Government has a lot to learn from this.

Enough has been debated on the economic liberalizations after 1991 and convictions of it are certainly fair. I see more as a principle of individual liberty, a life philosophy in a democratic base and less an economic imperative; and it must be beyond the dictate of state. Indeed it was a giant step on logical liberty from illogical behaviour of the state in controlling business, therefore it was an ascent to higher realizations in money, growth and enterprise in individual life. India has now a glamorous middle class and smart women; and their consuming life style being consumed by infinitude of choices in lustrous shopping malls, entertainment in hundred TV channels, and access to indulgence of the west. Growing productivity, very successful IT industry, smart communication, government earning heavy corporate tax revenue that is spent on social development programmes like NREGS, BRGF, IAP– all coming from removing some nonsense about individual selfishness for business expansion.

The political ideology of the other mind against liberalization I have sketched in another chapter, but going by democratic assumptions and liberty, to compromise with innovation and individual freedom for expansion in the name of *oceanic group interests* is

very much self-stifling for the very collective interest of nation. It is an assault to the fundamental independence of life that lies beyond rights of state, a principle that has been much debated long before in philosophic exercises on democracy and liberty of life.

Money is no longer a *maya*. Contrary to anguish of many that business people in India have not got that respect as politicians, film stars have got or as JRD Tata once spoke, people who have achieved through hard labour are not noted in this country, the post liberalisation has certainly started glorifying money, business and business people. The Indian mind languished long under British subjection, inherited psychic impression of an obsession for power to rule others. So political people and bureaucrats traditionally have got the attention because they speak power. Film stars have got the attention for glamour, dream, excitement and pleasure that they pump into peoples' mind. But making money traditionally has not been glorified, because Brahmins and *Khatriyas* are superior to business class, and India traditionally has a low opinion of money, business and traders, and a psychological prejudice towards business people that *beparis* know nothing except making money and profit; they are raw people who toil and make others toil from day to night. Physical labour is difficult, masculineness that gets scant respect, and the *baboo* like posture oozing power and command is therefore prestigious and glamorous. These irrational psychic

impressions are surely fading now under the pressure of democracy, recovery of lost-self and globalisation of economy. The same business people are now glamorous and *sanskritised*; Narayan Murthy has become a symbol of enlightened corporate. The vast entrepreneurial freedom and opportunity and the corporate success have given blow to the colonial and feudal psyche, changing the definition of power too. And sleek, high salary jobs in corporate sector with less bossism, scope for professionalism or a similar business enterprise of his own is now the desire of Indian youth.

The new economic doctrine has been a significant force in deciding righteousness in current times. The Indian is coming out of the lost-self and progressively logical. He is now able to assert himself with critical analytical thinking, may be in little faster after liberalization, which has given some autonomy to individuality. In a collapsing hierarchy in public life, the metaphysics of liberalization probably in line with Indian fantasy for progressive freedom and liberation from the limits of worldly existence. The new modernity is also sparking of a new trend in religious thinking, a more glorified religious enterprise rather. I would call it *respiritualization* of India, but this time there is a difference. The Hindu is now convinced that the world is not an illusion and the historical mistake of being other worldly is rather a dead end. The Indian is hopeful that its spirituality has some scientific basis, some even link to discoveries in psychological

science, in physics, and that spirituality could be a safe platform for rationalists but with an Indian obsession in oceanic feelings, without becoming religious, The *artha* dimension of Hindu *purusartha* is excited by the melt of asceticism, and the baleful influence of hot geography in Chaudhury's interpretation is now weak by comforts of technology.

The new material identity of Indian society is immensely making Indian beauties passionate, rather a revolution in creativity of glamour; some call it pink revolution. Indian women are reading between the lines of ethics, and have accepted glorification, endorsement of their beauty as an interpretation of the changing world, finding a scope and acceptance in broad domain of relativistic Indian ethics. The barbarization, hedonistic symptoms and materialistic interpretations, I do not feel a raze to interpret so, against our historical mistake of nasty compromises on life in otherworldly romance; I see it as some release of logical mind from material asceticism, but of course when modernity does not respect rules of democracy, a madness develops indeed.

## A theory of righteousness

I now end with my theory on Indian righteousness in contemporary times. The new modernity with liberty and competition is a force now. It carries a materialistic doctrine very much acting in the face of increasing

inequalities, new patterns of class conflicts basing on profession and income, but the new force is not alone an important factor. The fundamental historical-cultural impressions are very much effective, rather a major casual efficacy in current Indian society, and more effective being the colonial impact preventing our mind to think originally and regulating our day to day behavioural characters as noticed in Indian society like the following:

We are now impatient for self-expression because we tolerated long. We are impatient to make others listen to us and establish our individual identity.

We tend to impose our personal superiority on others because we were told to be inferior in our long subjection.

We look each other in inferiority often habitually because we accepted not our superiority but superiority of British. We see our incompetence, our lost-self in each other.

We often fail to observe the self honestly because we have not been of our own, we lack independent thinking, and feel secured in group thinking.

We are docile in fast recovery of lost-self because we feel hopeless as a hangover, for we have not been hawkish in our long resistance for freedom.

We at times do not understand democracy much because we have been the other mind.

We are not perfect or mathematical in collective, social actions because we are into actions, taking care of ourselves only recently, and we are very much family oriented.

We are impatient for the self interests and for locality because we were neglected and a big nation is a new experience for us.

There are three difficulties in resolving the above type conflicts, and in deciding righteousness across people, regions and groups in present times.

First, the modern Indian faces a bigger geography for ethical adjustments. India has been a continent by cultural plurality, but there was historical fragments and political disunity. Now a vast sovereignty. The Indian faces a broader radius to apply his ethics, from local geography, family and community obsessions to a wide nationalistic radius, which is his recent experience in history. He is reluctantly awake from loyalty to

historical fragments, and exists very much in a narrow radius. *His present crisis in ethics is in radius of geography.*

Second, democracy is the new religion of statecraft and constitution is its scripture. But Indian people are very much in the grip of belief systems other than democracy that she has not felt intensely for the character of her recent history. Still obsessive on many impressions of recent history and experiencing a conflict between the Constitution and behaviour in the society. He is yet to be a free mind to live in self-actualisation. This is the critical barrier for a good life and progressive democracy. *This is the great Indian shadow.*

Third, for a mathematical order in external world, in society, it is imperative that people should have wider perspective, an orientation towards the external, material existence, which is deficient in Indian psyche even in current times for his family obsessions and transcendental thinking. Indians are well versed in family matters but poor in social understandings. This is my thesis.

# Chapter 2

*We cannot move ahead smoothly with the experiences of recent history alone. People of India should read Kamasutra again as a symbolic indication.*

## Why Indians yield to Convenience than to Convictions

India is *bichitra*, difficult to understand I find even for the Indians. She is not a psychological continuity in her very long history; and she has many spells of retreats and excellence. The present Indian society in a recovery from the loss of self from recent history; and it is also difficult to connect present with the past perspective for a conclusion. Therefore the present has many confusions and imperfections; and it is often imperfect to give a simplified statement on good or bad about the Indian nation that is incredibly complex in living patterns and deep questions on life.

But Indian society tired me in last twenty years. There is little spiritually refreshing, all around a mind speaking die-hard obsession and taking positions in so many compromising convenience that further tires. In taking positions so, deciding justice, right from wrong, dominantly an Indian is first a Hindu mind. Family is very important to him. Then democracy and nationalistic thinking are the new challenges for adjustment of old ethics.

For the moral obsession on idea of righteousness, I have reason to pen down my feelings in the present book. Historians speak of the political ethics and life of people guided in ancient India by the principles of morality or *dharma* prescribed in numerous *dharmasastras* and *arthasastra* for ordinary people, for kings, for Brahmins, for family to follow in day to day life. Even for fulfilment of sexual desire, *Kamasutra*, a non-religious text instructs to observe the principles of individual and social ethics. Emperor Asoka developed an obsession for righteousness and pursued the policy of winning others through morality than by conquest, called *dharma-vijaya*. Even when battles broke, civilians, women and their property were unhurt, as an ethics of war; battles were prohibited in night, and unilateral attack in Mahabharata has been condemned. This is at least in principles, as a philosophy of living without going into the real organic relationship between kings and people in practice.

But the rule book was not without cruelty, ego and impulsiveness as in the war of Kalinga. There was also misrule like by kings of Nanda dynasty against which Chanakya raised voice. The dated history of Odisha starts from 261 B.C. with Kalinga war of Asoka who made an attack as a desire for territorial expansion. His forefathers failed to annex Kalinga and so he won the rich and formidable Kalinga only after a devastating savage war– a war so cruel that turned him into a pacifist. But what was the need of a cruel war and where is the ethics of attack when there was no previous attack from Kalinga, and the ethics of Asoka cannot be understood if we do not accept that it was narrowly confined to egoistic interests of kings and their kingdoms.

Basically why anybody should question the honesty of Indians against its long innate of tradition of pursuing a life spiritually and humanly at least in philosophy, which is very much innate in the Hindu view of life in eighty percent of Indian population. But it has answer in my view of changing geography and difficulty in adjustment that I am going tell.

The guiding theme of *Indian ethics (dharma)* is concluded in Mahabharata like the very common sense understanding of mutual existence: do not do unto others what you do not want other to do to you (*atmanah pratikulani paresham na samacharet*). It also means that such actions, thoughts and practices that promote physical, mental and spiritual happiness for one and

all are right. So it is relativistic, situational, pluralistic in approach in deciding the right from the wrong, like speaking an untruth for a good cause, instead of being guided by fixed principles. But the value neutrality character is not valueless; it has all these virtuous qualities like control over greed and ego, kindness etc. for happiness in physical, emotional, intellectual and spiritual life, which helps in sustenance of society. We are all conditioned, limited and in different states of consciousness, so there is no way to decide right and wrong absolutely for one and others. It is like the post-modernist interpretation of quantum physics that there are no truths fixed. There is no way of knowing the truth, which is a play of interpretations and how one perceives; it is not idiosyncratic and iconoclastic.

The Vedas use two words *Satya* and *Rita*. One is spiritual law of the universe and the other as working principle for manifestation of the spiritual law. The universal law is spiritual by nature and individual as an effect of the universe, should be guided by the same spiritual principles in deciding right and right, for establishing a harmony because life has also a responsibility towards god, besides to personal. The non -fulfilment gives punishments of rebirths and sufferings based on theory of karma. It bears answer on many of the ambiguous perceptions in everyday affairs in Indian life.

Indian ethics at times has also got some fixed characters. Under Buddhism and Jainism, ethics

got some fixed definitions like *tri-ratna* and *astanga marg* such as extreme non-violence, non-stealing, abstinence, non-possession of worldly objects similar to Christian and Islamic codes of fixed conduct. Excepting Charvak School of materialistic thought, all philosophies including the atheists like Buddhism, Jainism and Sankhya, advocate godliness in conduct. Patanjali speaks of *asteya* and *aparigraha* meaning abstinence and non-covetousness that are unlawful and unethical putting a ban on natural limits. This is all based on a doctrine as physicist Fred wolf believes, the nature of universe is spiritual, so we should behave spiritually. Or as Jogi Krishnanada writes, 'every event is a cosmic event and the universe is aware at every moment'. While following the pursuits of personal life, one should also be honest with god because the world is both *dharmakshetra* and *kurukshetra*, a cloister and a hearth. One has a responsibility to god as to life; you are expected to respond to every situation in moral, spiritual intensity; and you have a duty to yourself as to others.

Mahabharata is rich in dialogue on relativistic ethics, richer than Ramayana on ethical questions, for its encounters with difficult situations. Ram had to kill Bali; Angada has to be pacified and made a friend all for righteousness. For Bhisma, the ego of vow was more important than righteousness and punishing the divisive forces within the kingdom, but Krishna subordinated his vows by raising weapon for a higher

importance. Paradoxes, contradictions in applying relativistic ethics are very much noticed in Hindu scriptures and daily life of Indians, but the theoretical structure is assumed to be unchanged. As Krishnananda of the Himalayas says, one can see contradictions in the Gita. Statements of lord Krishna 'Go ahead and fight; 'think of me alone'; 'I am doing everything'; surrender to me' seem to be negating each other. But these are apparent only if rightly understood. *Brahma sutra* is an ancient Indian philosophical treatise, an interpretative textbook, and like a thread it connects different versions of truth, reconciles the apparent contradictions and brings harmony in the knowledge of reality. It is advised that an unprepared mind should not approach to understand the reality; one who has an open mind, has control over senses, is without ego, has virtues is only fit to understand the truth.

The apparent contradiction comes from a world view that is structured with dualities which are sometimes contradictory, sometimes complementary, cloister and hearth. So saying one thing and doing another is often noticed when a society does not follow fixed codes of conduct. Indian character has confused appearances, like the statements of Nirad that the Hindu for instance is aggressive while talking of pacifism, dirty in spite of ideology of purity, materialist while preaching spirituality, which may be accommodated in such interpretations of Hinduism. The Indian is unpredictable at times to the other Indian in daily life;

he may not be sure on their commitments; and he has his every explanation like breaking the sacred vows as Krishna did in Mahabharat, all supposed to be for upholding situational righteousness.

Unlike Hinduism, the Jain ethics does not offer possibility of excuse– one cannot escape sins through prayers but through right action and giving up all desires for an end to rebirth. So while a Jain may be strict about his action, a Hindu though innately human, enjoys a possibility of respite for his *papa* through numerous beliefs, scriptural prescriptions like bath in the Ganga river that may help one in getting escaped from punishment by social laws. Upanishad says that there is no excuse for bad works even if it is less and after the exhaust of good deeds, one gets result in next birth as per his bad deeds, but the Gita says that as heaps of straw can be destroyed, the mountain of errors committed by one in the past will be wiped out by the entry of knowledge of all being. Some attribute possible leniency in social ethics of Indians to such beliefs, but I do not see it as a major force regulating the Hindu ethics; it is a spiritual regret, to move ahead in life.

Moving from a relativistic, immensely pluralistic doctrine of life of ancient times at least as found in principle, in scriptures and some evidences, to ethics in modern Indian life, I find present Indians continuously speaking in hypocrisies, in indecisiveness. We have the ideals of democracy, but fall back on situations, blame situations for our inertia. We are slow, at places

on retreat on democratic progress and our mandates continue to perpetuate the viciousness; people do not hesitate to go against the democratic jurisprudence, a new picture that I am going tell now.

## A situational non-sense now

Watching the nature and exigency of unethical practices, I find the relativistic doctrine ghastly deficient to explain the affairs in current Indian life; *it speaks of situational non-sense than situational honesty.* Very undemocratic way of treating others in the name of equality, high unethical practices, a wide reluctance to accept the moral defeat, obsession for individual interests at the cost of social responsibility, religious kind of rationality, intellectual dishonesty and inertia, and an emerging intolerance against reasoning and dialogue, surely say that we do not do unto others morally. Speaking different things at different times, the Indians in present society are creating *circularity of logic* to defend their ethics of unjust practices which cannot be said to be free from illogical ego and brute interests. As journalist Francois Gautier of Pondicherry narrates dishonesty in public life:

'Look how Indians are in the habit of pushing other people, whether it is to enter a plane, or exit a cinema. Or how they so innocently ignore those who have been queuing for hours at some railway counter, by jumping at the head of the queue. And it is not only

the poor, but also the rich, who have this habit, witness the checking in at airports. Dishonesty is also a lack of collective discipline. Glimpse how the Indian man is often cheating, whether the poverty is only there because of the mismanagement, the dishonesty, the *tamas* and the inheritance of wrong structures. But it does not care, because the inertia in this country is so vast, so deeply and truly.'

How we have landed in such definition of righteousness, has a reply in the course of history both recent and obsessive past, if human behaviour is taken to be dominantly conditioned by his circumstances that I am trying to frame into a pattern here.

Politically, historians speak of sixteen republics in ancient India. It developed into kingdoms, never the kings have been united and it is possible to imagine that the political and ethical consideration was confined to narrow kingdoms and territories. There was of course annexation by peaceful means through marriage between kingdoms that unified territories. But the transitional episode of change in political dynasties is basically marked by treachery and killings for the throne. Even the Marathas who ruled for fifty years were not kind for Odisha. A treaty left Odisha to the Moghul ruler Alibardi khan who was to pay huge revenue annually to the Peswa of Maratha. A new system of middlemen feudal and Jamindars was created in medieval and British times exclusively to exploit and collect revenue and give it to the ruler. They paid

a fixed amount but collected in maximum; rolled in luxury, and were callous to people.

It well attests as Nirad Chaudhury sees Indian history to be full of wars and conflicts among kings, may not be at close intervals like the Guptas ruling for 200 years with political stability, and so he interpreted the Hindus as bloody, aggressive while talking of pacifism in their contradictory character and ethics. The geography of the kingdoms continually changed– people had to be loyal not to land but to kings. Like the personal theory of nationalism– Jayachandra inviting Mohammad Ghori for attacking Pritiviraj proves that nationalism or territorial loyalty was a concern of geographical fragments only. Similarly, Bhisma in Mahabharat stood against the division of Hastinapura so literally that he overlooked the logic behind rise of divisive forces and preferred to remain passive, even being a powerful warrior, during the infamous insult to Draupadi. So many deaths for a kingdom were the result of a righteousness of following a vow instead of meaning.

Though the medieval rule did not break the economic structure as the British did, it had periods of orthodoxy, religious terror and economic exploitation by self-seeking rulers. In my last visit to Hyderabad I took the help of an auto and its driver Salim who showed me different historical monuments like Salarjung museum and Golkonda fort. After I visited some places, he asked me how I felt. I expressed my not so good feelings, not

like others. I was carrying a different interpretation of history. Of ordinary people who might have taken great pains to carry the big stones to hills, unlike machines in modern age, for building Golkonda fort and whether they were reasonably paid by kings? But the tourist guides never give such descriptions; they only glorify the mighty of kings and the grandeur of monuments. So also in Salarjung museum– the craftsmen, artists have stretched their imagination to lofty heights to please the kings by their designs of so many dresses, utensils, furniture, and by the pressure of royal imagination. But whether they enjoyed all these and how much paid for the labor? There are also some photographs of royal dining by king and his family and servants standing back in sacrificing gestures. Auto driver Salim told me he never heard before such feelings that perhaps appealed to him.

And then runs the story of colonialism on Indian life– there was some integration, but largely alienation, exploitation and imposition of British superiority on the indigenous. It is possible to imagine insecurity, pursuit of situational ethics for territorial and individualistic exigencies. Narrow geographical interests have crept into the Indian mind for survival, making self-seeking instincts stronger, crystallizing into family interest first– *the dominant family theory*– in application of values and many conduct of situational non -sense in modern times.

# The narrow geography of ethics

It may be evident from historical adjustments and as I have said in the first chapter that the present crisis in application ethics by Indians falls in radius of geography. From family to a nation, the radius of sovereign, republic India is a difficult adjustment for post-independent Indians. The nationalistic radius is a broader geography and a new challenge. Her experience with honesty considerations on national scale is a recent experience in history against the long spell of ethical considerations confining to family, regional and local considerations. He is deeply attached to his family, which has been a guaranteed source of economic, emotional and physical security and support to life in the absence of guaranteed economic and social security even in the post-independent welfare state, and he feels more confident relying on his family and local relationships. Naturally, his ethical considerations are bound to gravitate towards family and other personal radius. Sudhir Kakar very well says that the Indian loses his face for negligence to family. Like a person in our village who is very much disliked by others for neglecting his family for a peculiar mindset. This may not be so a disgrace for negligence to larger social honesty. But in recent times people seem to be concerned in larger social interest, with law becoming active and strict on many unethical practices. The Indian makes culture-driven expenses for his family, on festive, on marriages,

on give and take kind of ritualistic relationships that is very compelling, instead of preferring individualistic and rational considerations. I had a peon in my office who in spite of meagre salary and personal difficulties was strict on many such broader family obligations, an obligation that he takes it as a duty.

Nirad Chaudhury lamented that nationalism may go down with the exit of British. While the Indian nation stands in her integrity, our present day nationalistic considerations are not without disturbing behaviour clinging to older historical fragments and regional considerations. Our honesty and fairness are still like squabbles of ancient times; still people misuse the diversity in Indian society and make a pretext for their ethical demands. We still favour our locals; so many contests in television programmes seem to be favoured by regional votes instead of excellence; and Indian states fighting for more devolution of central fund are indications of our territorial ethics. Language was the basis of formation of Indian states after independence, but in recent times some new states have been created beyond the language factor. And now a voice for a separate Bidarva state by dividing Maharastara has developed. In my state Odisha, some people in the western part claim that they are not *Odia* by grammar of language; and cherish the desire of a separate state that reminds me of the long episode of fragments in Indian history. Presently, a new conflict on a dam construction and distribution of Mahanadi

river water between Odisha and Chhatisgarh, has taken place. People of a state usually do not say that fellow Indians in other states deserve something; we only say we deserve this; and all possible logical understandings get blurred by self-righteousness. While speaking that we are all Indians, our national consciousness has still impressions of fragments and at times does not seem to prove this. While skewed regional privileges may be a reason, our unconscious regional affiliations speak of a deposit in mind from past geographical arrangements of kingdoms.

## *Easy westernization, difficult modernity*

The anglicized Indians after independence looked at politics as a scoundrels' business. The British culture and education brought values of modernity, scientific look, individual liberty, rationality, modern democracy, a secular, scientific jurisprudence, and *the great Indian inferiority* as well among Indians. The Indian stalwarts embedded values in the Indian renaissance for social excellence, but the renaissance did not spread to other parts in the priority of freedom movements.

When responsibility of nation fell on our shoulder after 1947, we inherited a weak sense of society for we were not used to it in our withheld citizenship, loyalty to regional fragments and family first doctrine and because society was a responsibility of the British. So instead of inclination for social excellence like

the few stalwarts in our renaissance movements, the middle class anglicised who also inherited Indian *inferiority,* preferred self-gratification in *babooism* in their inherited choice for civil service. As the way to it, they quickly adopted westernisation, rather felt secured in materialistic pursuits, and defined the hutch-pouch of politics to be a scoundrels' business. While my leftist ideologue friend says that politics is the highest and noblest profession, such impression is not certainly in the majority of Indians. The values of westernization, of consumerism and indulgence has won the pleasure of the materialist, insecure, hierarchical Hindu if I use a bit of Nirad's expression of Hindu character.

The obsession for family has been further spiced by the impact of consumerism, by the lure of liberalization, competitive market that targets to stimulate an appetite for more and more of demand . This is blamed by conservatives as the major force for the fall in morality, but it is a cue from Indian philosophical traditions to attribute many of the hedonistic behaviour to a life style of indulgence, greed, jealousy, covetousness, making the individual *charvak-like* to fulfill desires even by undermining values. While the traditional mind questions the basis of righteousness of the new Indian, the whole question of a fall in values gets struck with definitions of values in the changed view of life in face of new information.

'*The world is an illusion*' is the most popularly used statement to characterize the Hindu philosophy of life

and existence. But this view of life is surely crumbling under the new materialistic and glamorous identity of India after 1991. I at times heard the word *maya* that my father uttered to refer to the material world as illusory. In my youthful days, I did not understand how the material world so useful to life and existence can be false and meaningless. The conflicts and apparent contradictions are now clear to me as my philosophical sense has become stronger. Life cannot exist without the elements of external existence– air, water, food, house, different material and emotional needs. So for life in general, for you and me, the material world is a fact, may be in relative terms and may not be the whole truth for everybody, because of varied levels of desires and intuitive feelings, but it can never be false, for without different components of it, life is inconceivable.

Like me the modern Indian mind is reading between the lines with fragmented-analytical approach of the western mind. Technology and richness have made people confident to face challenges of life, instead of languishing in renunciation and melancholy. Life is both matter and other than matter, in new positions in modern Indian interpretations.

Amit Goswami, a philosophic minded quantum physicist speaks about the western mind based on Newtonian view of world though it is not the whole truth and some of its statements have been falsified by discoveries in Quantum physics in 20th century. The science has a dominating impact on life style in western

society unlike India where religion, intuition govern as a major force apart from logic. The Newtonian physics had also an interpretive view of society that became a dogma in western view of life in 17th century and ruled for three-hundred years and still is the dominant culture of the west, spreading to India too; and the interpretation was carried to all segments of life: That the universe is a material machine having building blocks; parts speak of the whole; universe and life having no meaning; survival is the purpose of life; observation is the only means of knowledge; consciousness, emotions, feelings are secondary phenomenon of matter having no casual efficacy of its own; spiritual experiences are unscientific and madness; happiness and well-being are directly related to material growth; matter is the end all and be all of life; nature can be manipulated and controlled for greater and greater comforts in life; and unlimited growth is possible through technology and exploitation of nature.

Giving stress on individualism, equating pleasure with material belongings, maximization of pleasure and minimization of sufferings, expansion and excellence in material life became the parameters in western life style. And the world saw its results: the material approach has delivered amazing comforts, richness, technological sophistication, value generation through big industries, great explorations of the mysteries in nature, and above all a scientific mastery over the external world of matter.

Today the new Indian does not understand *moksha* as an objective of life, may be it is not necessary in the age of technology and globalization that has stretched the limits of productivity and richness. And he has quickly grasped the typical western image. The youth today speaks of *'enjoy life'*, meaning more and more indulgence, maximization of pleasure and minimization of sufferings, surely has a location in the western imagery. When my son desires more and more of toys, accessories or enjoying food in outside restaurant, my father does not understand it, who always advised for minimum. It is not abstinence, rather more and more of *artha* and *kama*, with some good principles of course that is noticed in behaviour of modern Indians.

The liberalization of economic opportunity has favoured a materialistic romance; India is a material beauty now with glittering and entertaining shopping malls, beautiful cities, hundred TV channels, smart communications, glamorized middle class, shinning women, flooding restaurants, spoiling variety of consumables and comforts, and business cooperates not seeing limits in expansion through continuous innovations. In spite of merits of materialistic pursuits, the glamour has a lustful influence on disciplines of morality, more a danger in the already unjust platform of deprivations, intense inequality in Indian society, and unhealthy competition between rich and poor for land, for industry, for shelter. Numerous instances of

unethical activities going on have a location in class conflict, hostility and greed.

So also the confident erotic crimes on women in present times– hundred years of libido repression exploding into leachy behaviour of erotic indulgence both by male and female in freedoms and impacted by lustful, aggressive ads of corporate and westernization, sometimes breaking morality and creating increasing sexual crimes on women and unable to rationalize in conventional ethics of relationships that I am going to tell in some detail.

## The erotic crime & righteousness of sensuous beauty

Indians continue to remain lost on their historical continuity and antecedents of existing patterns of thinking. So we cannot observe the deficiencies in existing political-ideological correctedness that is not really helping to understand and find solutions to many problems like alarming sexual crimes on women. While people are emotional to accuse many aspects, we have to be mathematical to find the real solution, may be by adopting new social doctrines we are not used to. Let us start with the popular cause and find an equation in logical perspective to trace the first cause in current perspective.

Some views particularly the traditional spiritualist type accusing western sensuousness, seems to advice

for restraint, orthodoxy in sexuality; it is rather romantic in trying to impose a model of mind, to control such behaviour. The view may not be without some sense, but it is losing the historical antecedent of eroticism in ancient Indian life and then a spell of orthodoxy in Indian sexuality in medieval and British period. Uncritical restraint is again a question of possibility, attitude; everybody does not feel spiritual transcendence; everybody may not able to transcend the desires of body and mind like hunger and cold; and it may not also be right always to attempt so.

Other secular, leftist type of views speaks of social deprivations that girls in economically weaker sections who do not have the strength of positioning in society, become easy victims. On the criminal side, some theorize that social inequality, deprivations, competition and a hostile social environment breeding a criminal mind for erotic transformation of revengeful impulsions. Many also accuse the laws and communists accuse the competitive market economy that is using women's body in advertisements to win consumers to possessiveness, creating a lustful impact on psychology.

There were summers too in times of my fathers and grandfathers, but it was pleasant. Why the summer today is so hot? Deprivation, weak laws, beautiful women ever existed. How these are responsible now for the increasing incidence of rapes? To my mathematical mind, one thing is certain in recent times: release of libido repression, increasing sexuality of life with

a growing sense of individuality, liberalization of economy and globalisation of Indian society, which are not reversible.

The economic liberalization of markets might have helped the fluidity of erotic glamour through beauty pageants, but one may also view it as a new pattern of life, a new definition of beauty and psychology of grooming and gratification, which may not be wrong always like any other materialistic pursuit and creative desire of man. After all, beauty creates pleasant feelings and is loved by the psychological man. On the business and money side, as they say, the glorification of beauty through beauty contests has generated opportunities of business of huge turnover, from fashion designers to beauticians and beauty products. The Indian girls are reading between the lines of ethics and have accepted glorification and endorsement of their beauty. Glamour as a tool of marketing in capitalistic system may not be acceptable to confusing ethical Indians, but for Indian beauties this is an interpretation of the changing world, may not be always at the cost of values. This is like a renewed vibrant interest in the ancient *Charvak* philosophy of Indian materialism, of indulgence but not necessarily at the cost of total abnegation of ethics. The immediate solution to control increasing rapes may be a stringent law and its effective enforcement but the Indian society has to be awake to its complete historical truth of eroticism in her cultural history.

Then one methodological question: I find that the popular mind is for control through a strict law but feels less interested to understand the psyche of criminal-sexual behaviour. Many overlook other important aspects of understanding sexuality like the deficiency in existing family and social relationships to absorb the increased sexuality of attitude and impulsiveness in present times; the delay in marriage, and lack of education to understand the impulsive sexual behaviour and rationalize it. There are also innocent kinds of crimes out of infatuation and intimacy and then a mistake and crime like murder and escape of the criminal for fear of punishment.

Such an attitude may not be sustainable, because if we continue to reject an issue as undesirable like war, we may not be able to understand it. If we accept it as a problem in a mood of understanding, then only I see the wider scope of a solution. I would very much say to read writings on Indian sexuality by Sudhir Kakar, that ancient India and modern India show striking contrasts as regards sexuality, compared to other aspects of her civilization, like conservative attitude of today compared to liberal approach towards erotic life in ancient India. The erotic life in ancient times was advised of course with some moral principles to follow. And as Wendy Doniger says, Kamasutra is a wise book, not a dirty one and Vatsayana knew much more on sex than Sigmund Freud. But Indians show hesitance to take note of the proofs as found in temples and

scripture, rather some interpret the ancient erotic life in an altogether denigrating tone. People are confused, I find more shy to debate openly and widely on the issue of rape. I am speaking of an openness to guide the youth, particularly male folk; and in the absence of open awareness in present society, people of India should read *Kamasutra* as a symbolic preparedness to understand the wise aspects of sexual-ethical behaviour.

The righteousness of our repressive attitude cannot be understood properly unless we take the present orthodox mindset as a historical continuity and link to its antecedents and situational exigency probably in medieval and British times. When British criticized ours, we in defence denigrated ours, and accepted their orthodoxy and conservatism in sexual attitudes. I even came to know that the classic romantic-erotic poems of famous Odia poet Upendrabjanja was criticized, denigrated then by some under the influence of British Puritanism and superiority. Some also attribute to medieval society of religious oppression, at least in adopting conservative dress, long veil for women to hide their face, beauty as found in north India, whereas veil on head is not noticed in south India and not in women sculptured in ancient temples. This will help us to understand the truth of many aspects of our present sexual behaviour.

Indians seem to be opening their eyes and orthodoxy is melting into a *pink revolution* by women, some accuse and attribute it to culture of the west, but being awake

to our own historical truth will help to maintain our good tradition of plurality and argumentative dialogue. Of course in spite of sexual freedom, some western countries have probably higher rape crimes than that of India. In spite of so many understandings in social theory and social developments there, where is the success of western countries in controlling rapes? I was surprised to see such high statistics in internet. Westernization is likely to accelerate further the sexuality of attitude in Indian society and in this context India's spiritual traditions, a depth psychology in understanding and regulating the socially harmful desires of mind and body is a treasure; some convictions that not always by fulfilment but by transformation also, has scope of understanding the crime of sexuality, the violent desire of body and its imaginative impulses, which is wise to adopt for control of such harmful behaviour.

We may continue to persist in western superiority complex for historical and backwardness factors, but I see no mistake in experimenting with exotic cultures in a world of similar industrial and technological patters of living. The evolutionary psychologists while trying to explain the universal behaviour why every women wants to look beautiful and personal grooming matters very much for women, speak of the adapted behaviour of women in long evolutionary history of intense violence and competition in prehistoric times that to attract the capable male for her security and survival, woman used her beauty. The behaviour has changed

and in modern world where violence and insecurity have fallen drastically, the adapted behaviour still runs as a hangover and has got new meanings in trade economy and in the context of sexual awareness and gratification as a very personal desire in life. *Political-ideological correctedness may not be always helpful* and India needs correct, innovative social doctrines for better explanations on righteousness in many issues in current times.

The mathematics of society understanding in average Indian is bewildered, sometimes mystical, as if miracles should happen. For long we lived in geographical fragments and narrow interests, without political rights, hence without social responsibility that was left to British administration. We were not integrated into the ruling of our country, a long period of alienation in own land, alienation from political authority, and transferring the mind from generations to generations. Conflicts among independent kingdoms mark the pages of Indian history till the British came, when people got united geographically and psychologically into the Indian nation for movement against the rule. And our fight for democracy, for independence was mostly not assertive, not offensive and we had to bear sufferings and wait for a very long period to get independence. So we inherited a weak morale to solve problems point blank. While we understand very well the relationship interaction in family members, in our locality, we fail so in larger society. If five people are

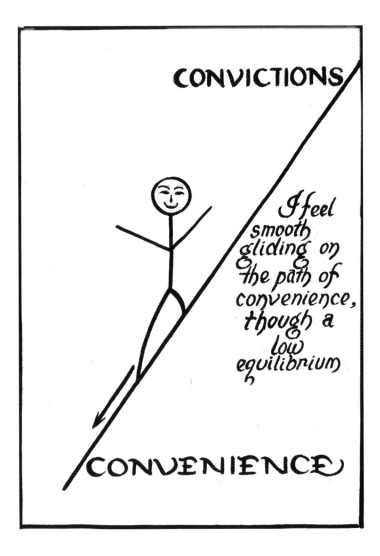

CONVICTIONS

I feel smooth gliding on the path of convenience, though a low equilibrium

CONVENIENCE

constructing house in a place, they give little attention to good roads, cleanliness, and they become aware of the external world only when it affects the personal interests. Our obsession for family, for self interest not experiencing similar drive for beauty in external existence. The world of the present Indian exists very much in family, in narrow radius of geographical fragments, an obsession that spoils his larger self as a nation.

*India is not a psychological continuity in history. Therefore we cannot move ahead smoothly with the experiences of recent history alone. The root of Indians is not located at a single point in past, but it has multiple locations of multiple excellence in different times. It is a root of beauty, of excellence, of own and convictions.* We need to be fully awake to our complete historical truth which is our collective unconscious. If Indians do not show a radical discontinuity in sangfroid for beauty in social world in this culturally incredible nation, then there are reasons to believe in statements and impulsiveness of Nirad Chaudhury, like a land of eternal conflicts and confusions, great contradictions, Indian acedia and a Circian land putting baleful influences on Indian character. The regression developed in Indian character in its historical subjection and oppression is still active as self-righteousness, apathy, group thinking and less independent mind. An insisting viciousness often becomes visible in my intuitive landscape watching the moods, the exercises in Indian society that is moving

more by mental impressions and less by convictions of the heart.

But the alluring democracy, the gradual strengthening of equality doctrine in progressive minded Indian society would continue to be the single powerful pressure for the retreat of undesirable impressions of history.

# Chapter 3

*Post-modernism in recent development debate has a basis but it does not replace modernism completely*

## Democracy is better than Development

The subject of development is better understandable in doctrines of political economy where literature perhaps ends in disappointments. But looking at material life of people in present India, I can see the obsessions of our cultural roots where economist's growth considerations, mathematical equilibrium also seem to be facing with disappointments. Years back I lost my interest in economics as I learned in college, for I could not find the effective cause of many important questions within the discipline and of backwardness in Indian society. The cultural landscape appeared to me a promising line for answers to my questions; and I went to understand Indian psyche, history, and sociology of class conflicts, to understand riddles in

current development practices. So I read Sudhir kakar, Nirad Chaudhury as much as I read Amartya Sen, Amit Bhadury and other free-market oriented doctrines in economic philosophy, for clues our obsessions and viciousness in economic-cultural-political psyche.

A satisfactory answer I find only when we accept, not question, the archaic convictions wherein pursuits of money and development go not in fragments but with other subtle righteousness. Sometimes back I was inclined for some rigorous academic work on current crisis in development conflicts, in economic theory and I have not gone further, but basically felt that people do not always seek to maximize monetary pursuits, they satisfy themselves. This is the biggest self-realization of Economics today. This is also prominently noticed in Indian behaviour adapted to heavy subjective considerations. Secondly, the world view of modernism and western business models is exceedingly monetised, materialistic and probably in conflict with the oriental world view of holism.

Indian psyche views life as an undifferentiated whole of gross and subtle needs; it boldly recognizes a *depth psyche* which academic psychologists do not recognize much, and the economic righteousness of life is not viewed in fragments but intimately adjusted with these two categories of needs. People seem to reject many offers of development in the current development exercises, not allured by the offers. Many big development initiatives are experiencing some tension

with the conventional world-view of growth principles adopted by policy makers in Indian situations like our many other western legacies.

Speaking socially, anything unscientific destroys the logical order and hence is ineffective in purpose and deliverance. People may be poor but manual labour is not always preferred to increase personal income. The poor too does not care for money where he is constrained to protect his subjective dimensions of life– poverty does not coarce him to prefer all kinds of hard manual works as noticed in vivid experiences. Because it may lack romantic appeals as a model of material view losing the sense of Indian cultural roots. It again reminds of Nirad Chaudhury who looks at Indian geography– its spring and rainy have intoxicating moods of complacency and cultural merry making even in times of technological comforts. And the summer puts baleful influence on hard work, propelling laziness; and *the Indian slips into mystic containment where manual aggressiveness with a weak body to end poverty finds little meaning for the poor.*

The grey side of our obsessive righteousness too brings disappointments. For example, there is a prosperous area in western Odisha where almost all agricultural lands are irrigated by the Hirakud dam water; one finds standing crops in fields throughout year; bumper harvest and well built houses of people. But I was appalled to see massive open defecation in main roads of village that I came to know to be the regular practice of people instead of using toilet.

Steps taken by district administration for toilets construction are not so welcomed, instead getting resistance by the obsessive fixation of some people. The rural sanitation programme has to be executed through some contribution by the beneficiary who is not often attracted by the idea. So it fails. Very much with self and family, the beauty in external world is not so important for the Indian mind, so the debris is expelled to outside of homes, even if it makes filthy of places. The step for *swatsha bharat* is a step toward correcting this psychic impression.

One naturally becomes impulsive watching the great contradictions of purity of mind and dirty in living and Nirad is provocatively innocent in his statements on Indian character. When the ex-Rural Development Minister Jayaram Ramesh says that temples are cleaner than toilets; people show greater interest in temples than in preventing open defecation, it genuinely points to difficulties governance faces for obsessive mindset of people and lack of their cooperation. The Indian view of life is not simplistically spiritual; it is not without irrationality from historical influences. So we have clean homes and filthy roads. Many hesitate to meddle in the matter of hygiene, not to hurt others' sentiments for the fear of unpopularity in community brotherhood, in a system wherein values and righteousness fall in a unanimous location and responsibility.

India's progress from top instead of firing from bottom is evident for our elite biased, imaginative,

idealistic, pro-mind instead of hard labour preference. The rural India if it has been developed is by percolations and proceeds from the top mostly. The ruling BJP government's direct transfer of funds to panchayats is a good step towards village planning. Some call it excess democracy and express apprehension. But democracy is a quality. The more of it, the more well would be democracy. But then democracy as a political philosophy, as a way of life in society, has some theoretical ideals like opportunities, capability for everybody. While this is step towards freedom, allowing people to take care of their villages and instilling confidence in them, our panchayati raj system in rural areas has also persisting cultural obsessions and peoples' inexperience in the process of taking the task of development on its shoulder. So the political class at the top and bureaucracy have to provide elitist visions and directions not to permit unscientific execution of ideals and not to make the whole exercise demoralising. Dipankar Gupta is nice in his expression of democratic ideals through an elitist intervention that people always need not be consulted for setting a vision. Nehru did not consult people for his socialistic ideals and scientific dreams; P.V Narasimha Rao consulted rather three economists for reforms of liberalisation. It is one Kurian or Swaminathan who in radical, dreamy, professional manner crated revolution in milk and agriculture production.

# The material liberty & story after

Economic liberalization of 1991 is India's ascent of material consciousness, and India is an emerging material beauty now for the ascent. It is a release from material asceticism, a recovery from a lost mind that did not glorify money, business and class of business people in recent history for many reasons. Gurcharan Das's *'India Unbound'* reads like a pathetic novel of private corporate during the License Raj, on a mind-set that stifled their freedom to innovate and expand on their own capital, and a possible high growth regime in pre 1991 period in spite of all the good arguments in pre-liberalisation times. The unholy version of human selfishness is an unconscious self-contradiction. Even a Jogi in Indian tradition who aspires for liberation of self, will not be successful unless he makes a serious, selfish move for God realization. So we rolled in a stagnant economic growth rate for forty years after independence.

Finally some genuine non-sense has been removed by Indian ruling class. But a new conflict emerges now that has questioned and brought to debate, the definition of development and conventional doctrines in economic philosophy. The free corporate tiger that has become innovative and expansive in new opportunities in last twenty years, is now obsessed with growth, creating new questions on rationality of growth at the cost of pollution, environmental threats,

and people's choice and emotions. That the Adam Smith theorem for capitalistic expansion has been used with exaggeration and writings of Amartya Sen, Kausik Basu have rediscovered that the invisible hand doctrine also carries importance of moral values like *dharma* in Indian tradition for a collective social happiness, which modern capitalism is found missing probably under the pressure of a bourgeois' philosophy or by a philosophy of material obsession culturally rooted in modernism and the western view of business ethics.

'*The face you are afraid to see*' a book by economist Amit Bhaduri reads like a novel of hopelessness. It points to the failed world view of development– the political system has no alternative but to adopt big investment of large private corporate. The state has adopted the conventional wisdom by giving land and other facilities to corporate– a corporate democracy as some say neglecting the benefits to people displaced for such projects and creating a bad face of development and political extremist activities. This has been the adopted mantra after liberalization. The TINA syndrome that THERE IS NO ALTERNATIVE to industrialization by private corporate investment as Amit Bhaduri says has influenced the development strategy across all political parties and then he points to a Gandhian style of self-sustaining villages etc. Not so not alluring, not romantic. *This may be the old story, very boring!* His other book *Development with Dignity* is towards a more democratic economic enterprise at local levels.

The skill India initiative of BJP government is may be a similar step towards strengthening capability of larger and larger population at local levels, among the poor for participation and competitiveness in free economy.

Leftist economist Pravat Patnaik says, the new phase of economic liberalism converts economics from a scientific discipline to an ideological tool for imperialist hegemony. An obsessive growth without many jobs shall bring its own collapse through a deficiency in demand. So a more democratic economic enterprise with wider individual capability, value generation and income growth by exploiting the local resources, shall bring a broad based development without displacement or exploitation, a development with dignity, instead of relying solely on big corporate. The present book is not meant to be a rigorous work on such topics, but speaking in a language of literature and feelings, the mathematics of arguments in alternative policies cannot be complete in itself. Because Economics is not like a physical science. It operates through Man; it has to fulfil some psychological necessities beyond economic considerations like selection of an economic agent, the space to operate, and peoples' psyche in a democratic society. The accumulation of capital has been more *romantic,* easier through a free hand, free mind than otherwise. This is the essential metaphysical nature of man in economic enterprise.

Kalinganagar in Odisha is an emerging steel hub of India. The area has been declared as the national

manufacturing zone. Eleven companies are producing steel and others. TATA has installed its plant on the acquired land that has displaced about a thousand tribal families of their house and agriculture land. The acquisition process was painful, psychologically uprooting ultimately resulting in violence and firing in 2006 that killed twelve tribal people and one police. People of different ideologies have come to this palace to see the displacement process. After all this, TATA has built three rehabilitation colonies for the families on land given by government, where the families have been kept with basic facilities. Some monthly package for ration expenses also is provided. TATA company has given jobs to many families. They have got a life in industry and future urbanization. Industry with a human face has proved that displacement does not bring poverty; romanticism of environment, of rural life may not always be the right path to human aspirations. But I should say that the present realization of corporate and ruling class is the result of a serious dialogue, new theoretical understandings of development meanings, and different agitations in last few years in India.

The poverty magnitude in India has fallen to 28% of population but a radical approach of many others criticises neo-liberalism, displacement, giving resources to private corporate and speaks of a higher level of poverty, and the millionaires who have multiplied in Indian society. In recent times the debate has got some significance in view of pictures of inequality after

liberalisation of economy, reduction in organised sector employment and increase in unorganised sector jobs. But I have a feeling that facts do not adequately cover the benefits from expansion of business opportunity in private sector and I doubt whether the statistics on jobs created in unorganised sector in last twenty years and their salary speak of the reality contrary to such criticisms.

While there cannot be any question for a responsible regulation of free market by the state and taking compensatory steps in government like IAP, mineral development fund or providing houses to slum dwellers, as a democratic fairness to the affected in painful exercises, the dominant feelings in Indian society are not inclined to judge liberalisation just in terms of poverty, imperial hegemony or inequality. The interpretation popularly is unromantic in view of aspirations of low and middle class Indians already exposed to the glitter of globalisation and the righteousness of which I have told in the first chapter that this is something to accept for *trans economic convictions*.

## *Who are you to define development?*

The current conflicts in development definitions indicate an intense mist! *This is a much deeper economic righteousness which I find difficult to accommodate within the left or right of ideology.* While the rightist obsession for growth overlooks class conflicts which

leftist takes care, the leftist approach of expansion blames religious environmentalism and environmental romanticism, which create blockades for growth and therefore such approach to life is not appreciated. As in issues of land acquisition for industry, the process of development has been facing the arguments of gain and loss, which is not very acceptable to both sides, because one is a conventional idea and the other questioning the conventional wisdom adopted in development process. Some view it as meaningless and some others recognizing a rational basis. The tribal in Gandhamardan hills of Odisha rejecting Vedanta alumina project, may be a typology of such romanticism and apprehensive class deprivation. But then whether it leaves any scope in ideology to accommodate the cultural convictions and rights of people? Liberal democracy does accepts it, I feel, for life after all, first belongs to the individual, and he should define how to live. When the individual is free and has access to resources and capability as a democratic right, it brings development in its own way but development without opportunities of freedom and access to resources, blocks many for progress.

The choice also finds place in post-modernism that rejects authority of any knowledge, fixed patterns of truth, right and references. It recognises possibilities of new patters for living– the individual is the supreme authority of himself, and no one has any right to say what the other should do. Post-modernism too is criticised as being an arbitrary play by individual,

not being universal truths etc. But this is a new world where primacy of subtle dimension in human nature is recognized boldly– a transition from measuring growth by income to well-being including psychological happiness. And justice to such considerations cannot be made, unless we listen to the possibility in post-modernism. President Jose Mujica of Uruguay has been reported as the poorest president in the world. But he does not understand the level of being the poorest and probably seems to say that he is happy in his way of humble living that defies the official definition of poor and modernist notion of measurement by material parameter.

We have to only understand that some do not understand the patterns of development what conventional theorists and modern society mean, with the single aim of more production and more consumption in innumerable varieties of necessity. In one sense they defy the modernist definition of development. *But it does not mean that their idea of life completely replaces that of ours. The fundamental questions of food, housing and sustenance are also there in tribal living. Post-modernism therefore cannot replace modernism completely. And it would be an error in philosophy to replace the logic, fundamental scientific truths in modernism.* Either we have to rewrite development philosophy or reject their verdict as misguided politically.

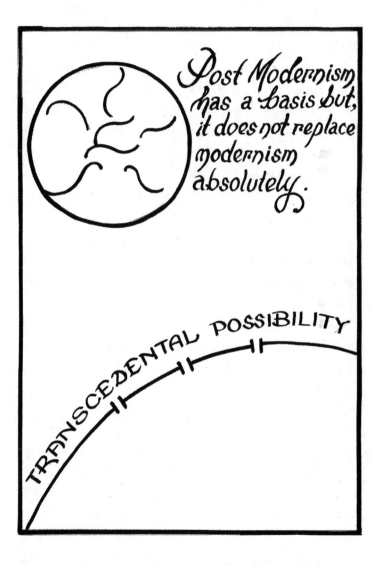

Post Modernism has a basis but, it does not replace modernism absolutely.

TRANSCEDENTAL POSSIBILITY

This is also experienced in broader Indian view of life. People live intuitively along with material aspirations of existence; a spiritual behaviour is profusely noticed and well understood if not always followed; feelings of interconnectedness in relationships, resolving in mind than in matter, feelings of complacency even with moderate livings, focusing on meaning and spirit than structural formality even while following modern patterns of living are there, and such spirituality is easily recalled in Indian mind. Because this is our collective unconscious, may be our convictions. In one sense I find the behaviour rational, not always mystic, not nonsense.

The contemporary conflicts, the divergent ideas and process of development are indicating a need for creative way of reasoning for a new economic righteousness. And the new doctrine certainly cannot be outside of cultural convictions. The difficulties of understanding the tribal priority or even the scepticism of conventional wisdom have scope of better understanding only if we go beyond the conventional wisdom and question its limitations. Like in conventional sense, low income is not added with judgments of well-being considerations like clean air, water and primacy of subtle emotional happiness. The economic health of individual becomes equivalent to the quantum of income he earns. But in the new world view, a low income may not be necessarily always less developed when it fulfils others aspects and psychic preferences. For difficulties in modernism, post-modernism seems to offer some solutions.

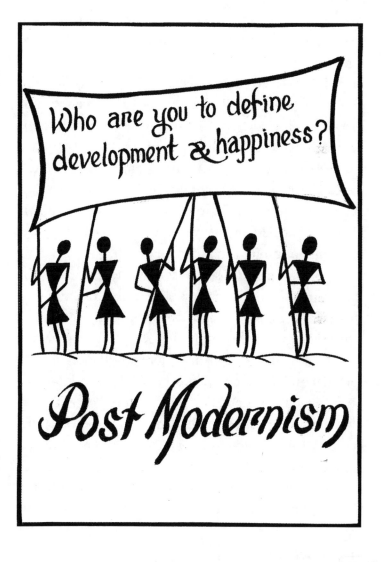

The conventional philosophy of growth based on a material view, has perused a belief that man always runs after more and more of economic gains; this is the doctrine that fails to understand some intuitive questions in human nature including his economic pursuits. Western-accent economic pundits for the reason of being levelled as unscientific, feels shy of uttering spirituality. Of course it has the danger of trespassing and talking in religious terms and inviting irrationality. They do not understand spirituality, instead talk of values,morality or legalised codes in economic policy perhaps after seriousness shown by Amartya Sen by reinventing the morality based principles of capitalism of Adam Smith.

A spiritual patter of society is now a new buzz word in 21st century. Physicist-philosopher Amit Goswami says that the future road map is consciousness economics, which recognizes the spiritual urge as a human nature and by investing in more and more production of such spiritual capital, man develops a desire for containment, positive manifestation of creativity, instead of becoming obsessive for growth, greed and covetousness. And India in this sphere has a lot to show the path to the world. Some philosophers call it trans-modernism after the discovery of quantum physics and the different philosophic interpretations associated with this on reality of existence. They interpret the universe and life in spiritual lines like Fred Wolf saying that the universe is spiritual in nature, so we should be spiritual

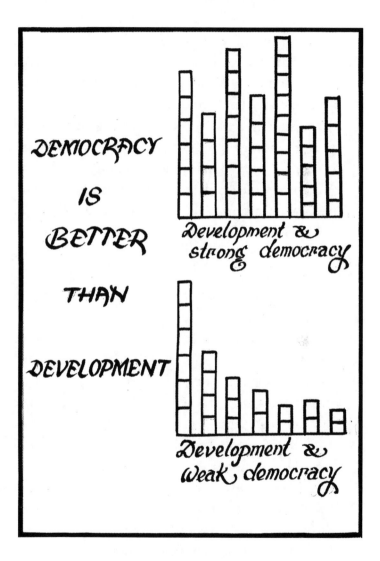

DEMOCRACY

IS

BETTER

THAN

DEVELOPMENT

Development &
strong democracy

Development &
weak democracy

in our behaviour. What the discovery of quantum world may mean for reality is also extended by some to society including economic philosophy, that we are all interconnected, there are no fixed truths of living, and therefore we should go beyond habitual dictate of mind and see the truth creatively and live accordingly by choosing new patters of life. Though a spiritual life generally is taken to be humble in material possessions, the *difficulty* lies in defining spirituality and enforcing it in correct mechanisms, and everybody may not be inclined for a spiritual living, and there are physicists and atheist like Victor Stinger vehemently going against such interpretations of science.

## *A spiritual crisis in theory*

Mathematically glamorous modern economics started with a physics-envy mindset in USA and took up emotions of glamorising itself like prestigious Physics, with language of mathematics and objectivity. The approach was perhaps not completely an independent mind, so it overlooked the immeasurable emotional dimension of human nature; it forced the economic behaviour of man to fit into theorists' idealized models instead of fitting the model with the reality of man's economic behaviour. Economists have tried for impossibility, which physicists also do not understand and express their surprises because models in physics become scientific only after getting verified by real

world findings whereas economics has gone the other way. Because it was thought in a time of materialism that man can be forced to accept it and his emotions can be overlooked in the fulfilling of material pursuits.

The overly material model of modern economics was inspired by the Newtonian view of world that became a dogma in western view of life in 17th century and still is the dominant culture of the west. The interpretive message of Newtonian view was followed in all segments of life– consciousness, emotions, feelings are secondary phenomenon of matter having no casual efficacy of its own; nature can be dominated, controlled and exploited for greater and greater comforts in life; and unlimited growth is possible through more and more exploitation of nature.

So the conventional theory on economic choice has been underestimating the primacy of consciousness considerations and pursuing the deterministic belief that the behaviour of man (*a material man!*) can be fitted to barricades of idealized mathematical models. And growth theorists later on being motivated by political ideology of capitalism and growth, allured by capitalists' business interests, embedded the thoughts in text books that spread all over the world. When I was reading in college I found only a uniform message in text books that through higher savings, higher investment and productivity enhancing technology, profits come not only to individual business but it also brings growth, employment and end of poverty in

society. And the subject of development economics was also influenced by this.

Whenever I open the websites of economics departments of leading universities in world, I find graphics of mathematics. It looks like physics or mathematics department. I see it as unnatural. Mathematics is not the primary tool; understanding the behaviour of economic life is important; and psyche has its own way of precise of expression. For example man loves happiness not sufferings. This fundamental human nature needs no use of mathematics. The use of mathematics for objectivity and scientific analysis for building precise models, apart from being useful, has also done damage to subjective considerations and judgements and neglected richness of human psyche in economic life. *This is certainly a spiritual crisis, a crisis in deeper meaning in Economics. I feel many theories can be harvested without the use of too fragmented objectivity, and we can predict better relying on subjective richness of human behaviour.*

After devastation in 2nd world war, the world needed a growth regime in the face of scarcity. India had green evolution through genetically improved seeds, but the growth obsession is now breeding aberrations like pollution of land and water, expensive agriculture and farmer suicide. I have read different views suggesting solutions for farmers' suicide such as providing cheap credit, waving credit, socially conditioning the farmers to abstain from excessive social expenditure etc. These

are to me fragmented and reductionist again relying on the complicated mechanism of society. These are only shock absorbers and do not seem to deeply understand the problem in capitalist expansion of agro-business. The hi-tech seed used by Indian farmers cannot be recycled frequently and therefore need to be purchased always, which requires heavy manures and pesticides making the agriculture operation expensive, which was but basically depended on nature before such technology in agriculture was adopted. In case farmers do not get returns against the expenses, it amounts to double suicide– loss of crop and indebtedness. Green revolution did make us self- sufficient in food by the use of hi-tech seeds and it may not be wise to reverse the process, but the policy thinkers have to retrace their steps to understand the missing links that has led to the suicide of farmers and other such issues in agriculture.

A major blow to economics after the global meltdown of 2008 created conditions for soul searching, and an ascent of realization is now felt around. Nobody could predict the recession for the wrong assumption of the theoretical understandings. Understanding human behaviour has been the single greatest obstacle for economics in current times and economists experiencing incompleteness of earlier generalisation on homogeneous, profit maximising aim of human nature and economic behaviour. It is not recession alone, but the whole difficulties of corporate desire for land, for growth in developing countries, inequality,

feelings of unsustainable growth in face of pollution, over-consumption in rich countries, environmental threats, have created conditions for developing a better comprehensive model. The Income based index of development is not discounted by monetary value of negatives like polluted air, environment, stress, psychosomatic diseases, risk factor and less freedom for emotional fulfilments. Similarly low income is not added with positives i.e absence of all these. So in this changed world view, low income may not necessarily be always less developed.

Necessity for a new world order in economic philosophy of life in view of the crisis in economic philosophy and in economies in different countries is felt by many as I see in internet articles. I see a voice to induct more meaning, spirituality, human psyche in economics and not to use meaningless mathematics. I support such convictions. But I take the issue cautiously. A need for strong theoretical works to avoid confusions and confirming the metaphysical basis in economics. Because spiritual madness is as dangerous as a raw material approach to life. I am worried by both. But this is increasingly becoming clear, demystified by intuitive understandings and psychological revelations like postmodernism in development concept. We have admitted ethical considerations on social interdependence but there are also signs of failures in mechanism to enforce the values, pointing to an intuitive leap for internal

transformation in our convictions. To capture the world of consciousness which is subjective and mostly non-linear, we need to go beyond mathematics based deductive modelling. Kausik Basu writing 'Beyond economics', Amit Bhadury speaking about collapse of neoclassical thoughts, and some searching or a dream theory of everything in economics similar to unified theory in Physics, are the developments towards soul-searching. If modernism guided modern economics in 18th century, the philosophic significance of possibility beyond the rigid rules called postmodernism may guide new economics in 21st century– a theoretical world where growth, sustenance and psychological well-being will be assured. A theory of everything is very much conceivable in economics, because the economic behaviour is well within the observation and felt in experiences unlike Physics. Only the inner order of equilibrium needs exploration; and a hard theoretical work is required before the world accepts an alternative economics and economic life.

From growth to importance of well-being including psychological aspect in measuring the progress of countries, I find in World Bank reports, but who will bring it to practice and why unless the persisting view of life changes. But the new questions are creating conditions for new thinking and an intuitive perception. Like Physicist Fred Wolf's reply to my question on how a philosophic minded physicist perceives global

economic crisis, the obsessive growth and democracy sometimes behaving like plutocracy. He says:

'Life goes on. As such, after fear and disinterest have reached their eventual peaks, we soon become less fearful and more interested in the things we desire. Hence we continually create a trade economy. There will always be ups and downs, upsets of balances and rebalancing, and interests varying and agreements changing in such an economy. It is a story of evolution as convoluted as any biological mechanism can be. Hence I perceive life as a continuing battle of spirit with matter– a war with time we all fight continually.'

United Nations recently has adopted sustainable development goals as a global agenda for all countries in view of the economic riddles the world is facing. This at least theoretically means that the world should move towards more of democracy for more and more people, every body's well being, not just a wild development.

And I have learned something wise, useful in postmodernism, feel liberating, a mathematical gain, watching the complexity, the too fragmented thinking, sometimes suffocations in complexity of modern life and modernism.

# Chapter 4

*The most visible pattern in present times Indian democracy is that it has derailed from some of the theoretical conditions of the very political doctrine.*

## Theoretical Anarchy in Political Doctrines

Democracy is the fundamental theoretical idea to guide all our societal existence in modern India. And all our political doctrines should progressively enrich the actualisation of this collective philosophy moving India from a feudal-irrational impressions of the past. But it is noticed that many attitudes,actions in our society are creating irrationality, anarchy of new types, with a pattern of course, mutually inconsistent, and not going well with the spirit of Indian constitution, and not favouring the undisturbed progress of justice, equality and dignity considerations.

What was the original idea behind the development of democracy in history as a political and social

philosophy that has been accepted world over for its alluring doctrines of equality and freedom and how far Indian democracy has gone?

## *Pattern in politics of democracy*

Equality the crowning doctrine of democracy. Going by this, the big success is that Indian democracy has shown balance of power across political parties with reduced monopoly in politics. Now a sort of perfect competitive market, there is a competition, fight more for better performance and less on unfair priorities. Different political parties are drawing strategy to win people with laudable policies and programmes, and like corporate they are also using media well for propagation of their achievements. But then for complexity in Indian society, the interests, the groups still very much take a win in election as supremely important and they are in exploration of all weak points to capitalise on voters. At the individual level the equality doctrine is now stronger with reduced hierarchy and assertion of individuality in public life; women are more expressive and ambitious; people in higher rank are also punished by law as people in lower rank, a democratic pressure mounting on hierarchical and unequal Indian society in different spheres.

Second, the pattern emerging contradictorily is that democracy has derailed from some of the theoretical conditions of the very political, creating a theoretical inconsistency. The most popular being that political

# ELECTION

# DEMOCRACY

The instrument has become more important than the ultimate purpose!

parties have taken *an instrument i.e. election* as supremely important so much so losing an election is not an arithmetic or ideological loss but appears to be a painful Indian insecurity like losing a valuable asset! Popularly Indians notice a contrast between pre and post-election characteristics of elected representatives and in their democratic credibility. The ultimate test of election is the democratic credibility of peoples' representative, an enlightened leadership, and commitment to democratic values that appears to be the reluctant priority of many in light of many instances in present society.

Third, I find a deficiency of innovative interpretations, an ideological rigidity. All issues are analysed in usual style of left and right: either somebody is a fascist, religious type or a secular, democratic type, and people are also guided accordingly. Either industry or no industry. Either a Hindu fundamentalist or a liberal, secular Indian. The mindset is deficient in new patters of thinking in between, as if the universe, human nature and Indian history fall into these two divisions! This is the old style, very boring! This is the post-colonial western superiority and Indian inferiority, and is blind to aspects of our historical excellence and living patterns because of our some intellectual servility. I am not inclined to accept the rigidity as *a correct political doctrine* for India watching the richness in Indian psyche that crosses this simplified theoretical barrier.

Four, when we had Nehru, Patel, Basu, Namboodripad or Narasimha Rao, this *philosopher king* leadership has faded in last twenty years, and a leadership without theoretical vision and creative understandings has came to occupy the important positions. Indian democracy is developing symptoms as a rule of will of people over rule of mind and constitutional jurisprudence. In the priority of election and votes, an anarchical tendency by bringing individual doctrines in religion, caste, region and groups into politics is disturbing the equality doctrine and rationalisation of inequities in proper perspective.

Five, Indian democracy is running without adequate citizenship education as a cultural-mental preparedness on theoretical ideas and conditions of democracy. Recent statistics that polling in cities is much less than in rural areas indicates that urbanites finding a gap between voting and representation and credibility, losing interest in election exercises. Sense of equality, freedom yet to get respite from religious paralysis and individuality; and a free mind crossing over historical impressions is yet to be a mass phenomenon.

Indian public for their faith in sanctity and independence of judiciary, have created situations for the Supreme Court in its judicial activism of watching the society actively. I found it funny when I tried to know why there is a not a speed breaker on a national highway having a college on the other side, because of which accidents and death have occurred, one local

officer told me that supreme court has given a ruling not to keep speed barkers on NH. So they have deployed one police on the spot. But I could not understand why supreme court had to give ruling on a matter so small when this is very much a technical decision of executive. It means some body has challenged the mind, the fairness of executive in the court. In many cases government is also winning but people are found to be inadequate in understanding, and not having patience to understand the fairness of executive procedure watching the language of righteousness as close onlookers.

Let me start with political romanticism either leftist ideology or rightist aspiring for a radical change on existing practices in Indian society. Some political movements are romantic in their imaginations like the early movements of Kejriwal or Ramdev or that of ultra-left, rather hawkish as powerful interveners in democracy to put pressure on government to give shape to their romantic theory. But there is a theoretical difficulty in their romanticism that I am going to tell.

Steven Pinker is a Harvard psychologist and author of *The Black Slate,* who refers to a long adopted behaviour in evolutionary history as one factor to explain many of human behaviour and which is not explained within any social environment or by any factor within one's life time. He says that a human baby is not a blank mind but carries some inherited adapted behaviour from evolutionary history of man and everything is

not possible by putting a gun on the head or by social engineering which has to take considerations of the predispositions before taking a position. For example every women world over wants to look beautiful and is noticed to be more caring in grooming than men, not because of any prevailing social factor but due to a reason in long past of evolutionary behaviour that to attract capable men for security in a competitive system, women used their beauty that they learned in the process. Therefore an artist may create lofty romanticism on a white paper but society is not a black slate that has compelling forces of psyche, and many do not always respond to environment to change their behaviour. The black slate theory is a strong challenge as to why environmental and social conditioning and law fail sometimes to change peoples' behaviour, because of some formidable presence in psyche. It does not mean we should use the base to support unjust action, but a sympathetic understanding of it helps to take right kind of position, for positive rationalization of undesirable nature by creating suitable environment for the change.

In this context, I was disillusioned to see that many questions on ethical issues are religious like. But very soon I realized my innocence. The subject that was emotional for me fifteen years back became an issue of intense understanding both in abstract and reality in view of recent happenings, a conviction that like the inherited human nature there are orders in human

society along with freedom and randomness and the good and evil are only spectrums of different intensity in a colour band. I came across the speech of Noble laureate Aumann on rationality of war. The way he approached the issue of war shows the significance of value neutrality. That war is not always undesirable or evil, and by accepting the problem rather than rejecting it, has the better opportunity of a solution.

Poverty is the inducing factor in my convictions, for many people resorting to different kinds of backdoor, unethical practices. These are the inherited compulsions; and so a feeling that imposing an honesty that is cruel to existing structure may create a bigger dishonesty. And people I find seem to be disillusioned by the problem, a hazy understanding and confusions on solution; and I see greater hope in creative corrections of the problem keeping in perspective the constraints of Indian society, like the need I feel for a large scale pension for guaranteed economic security for every unprotected Indian to build up a confidence of living, to reduce the anxiety of survival through illegal and unethical pursuits and for subsequent support to stricter laws.

Social inequality, increasing awareness and individualism have complicated the phenomenon of unethical practices further. Some go beyond the norms of society and feel it as inadequate– ethics is neither black nor white, anything done to justify class conflicts is not unjust– and there are many shades of grey in

contemporary relativistic ethics of Indians. Honest people in government I perceive to be god-fearing, ambitious for good name, scared of rules, respecting legal ethics of society, and do not have psychological drive to get into hotchpotch to derive extra benefits or either of these. My father used to maintain high standards of ethics in his service life. I heard him talking on ethics maintained by early chief ministers of Odisha after independence. India became independent and the whole nation was inspired by leaders of high morale. The hangover continued for some time after independence, in politics and government.

Looking to the society critically has become stronger; the question of society against individual interests has surfaced clearly; and Indian leaders are also interpreting interests of the nation in patterns of individual and class interests. Today industrialization that is essential for fast economic growth is being questioned on the basis of who are going to get benefits and who are going to lose land, water and other resources for industry. Induction of political economy, an approach of analysing economic decisions in terms or class realities is certainly a critical manifestation of the Indian mind, and public ethics is being interpreted in light of happenings in larger society as an interrelated existence.

Another black slate impression that a romantic finds difficult to win for the incorrect doctrine, I am going to tell now.

# Indians do not prefer to be socially aggressive

I remember one leftist writer who wrote in a newspaper article after launch of *Hary Poter*, a book of fantasy that this is social escapism by diverting attention from reality of society to fantasy. Apparently leftist intellectuals mean that it intoxicates readers' minds not to think of social problems. I do not agree theoretically. It is impossible to live always with reality, with limited societal existence and it is also not a compulsion to expect so from everybody in a liberal society, because life first belongs to the individual, then to the state. *Society is not everything in Indian view of life.* Life belongs to the entire universe offering a scope of infinitude, therefore Indian cultural traditions have multitude of transcendental opportunities to live beyond the limits and disillusionments of society and material existence. Creative imaginations, transcendence have always inspired humanity for better life, for a higher order reality, at least psychologically, like plenty of scope in Indian spiritual systems of living and Indians despite social imperfections are able to live and derive some peace because of such opportunities of living life beyond the dictates of society. We are not a nation of French revolution, though there is a tension in fairness in modern Indian society.

*It leaves a question and provides a clue why Indians are poor in social mathematics and nor they feel need of social aggressiveness or feel wise to take positions so always.*

*This to my theoretical mind, is the factor for people not so much appreciating the language of communists in India.*

Believing in materialistic interpretations of social problems and even culture that everything has connection with economic aspects, communist leaders I find non-materialistic in their personal life style and socially honest like my leftist friend Govinda Maharana having a cycle and a single room house. They ultimately desire to finish the dictate of mater (commodity fetishism) in deciding the human relations and affairs of society. A cashless world! I did read the great theoretical structures of leftist philosophy, but not felt so attracted to their doctrine except some scientific social analysis and intellectual personality of its leaders; but in their thesis of transfer of power from British to Indian feudal, capitalists, an impression that is still alive, responsible for similar mindset in the process followed, a convincing truth is there. Indian communists are one oldest political party, their commitment for larger social cause is unquestionable in electoral or non-electoral politics, yet I am puzzled to see that they are by large out of Indians' appreciations; even the poor, the proletariat they represent recognize better BJP, BJD, Congress, not leftists, because they too want to be rich like other riches, dreamy, and desire not to live in charmless equality of restricted personal expansion. So if one is not popular it is not possible to expand politically and spread the ideologue further. Without going hard into theory, certain things I find

unnatural in leftists, in my immediate feelings and against Indian psyche.

First, communists do not seem to appreciate heights of fantasy on both fronts: material and transcendental, sex and god and confine society within reality, leaving no vent beyond and discouraging all flight and imaginations. To my theoretical mind, leftists do no appeal to the cultural, philosophical convictions of Indian peoples' psyche, which is prominently too mind driven.

Second, the leftist emancipation of mankind through state dictatorship on the Indian democratic platform, speaks of fundamental contradiction, not possible in liberal democracy of personal liberty in many dimensions. The accumulation of capital has become efficient, more practicable, and romantic in innumerable manifestations after liberalization of economy in 1991, and leftists' criticism of neo-colonial, economic hegemony get sore in convictions of a liberal democracy and trans economic factors that I have told in other chapters.

Third, the dominant Hindu mind carries formidable convictions of disillusionment with life, pleasure in transcendence, hope in other world creativity, innate spirituality, resolving many questions in mind and in internal world of self, freedom seeking with fantasy of liberation, instead of being hawkish about collective life and existence. For Indians a religion divorced life

is unthinkable when from morning to night, the day starts and ends with god. Religious considerations along with logic and rationality go in daily Indian life; Indians carry an innate spiritual and unorthodox approach to religion; secularism may decide the affairs in governance and public life, but Indians do not understand much the atheist language of leftists. And all these rather fit with a liberal cultural setup.

If the rightists have divided, the left parties too have divided among themselves but they still hold Marx as their godfather. Their inter conflicts, hair splitting differences on the design of correct Indian doctrine, responsible for multiple left parties including Naxal, all boring, appearing to be in illusions and delusions. SUCI tells that it is the only genuine left party and they treat others as revisionists, bourgeois like who have made mistakes theoretically, as my leftist friend Govinda narrated to me once in a restaurant. In Odisha or elsewhere big left parties are going to other parties except to BJP for the secular alliance– anything else is acceptable than religious fundamentalism! And left parties live like a parasite depending on others for their victory and they blame their ideological sisters like Congress party for defeat of the secular alliance.

Further, in their extreme scientific thinking, there is no scope of innocent faith, and leftists do not seem to appreciate transcendental thinking, without which this may create a sort of madness in limited existence, and I had the similar experience once when society

was constantly in my mind till 2014. In 2015 I became convinced and I realised that I should read words of both Bartarnd Russel and Geetagovind, reality and transcendental else there is every scope of melancholy in Indian conditions.

Leftists are not so acceptable to Indian convictions, more made worse by their suicidal behaviour. For reasons in Indian character, Nirad Chaudhury also wrote that the efforts of leftists are a great waste of time, and India cannot be a communist country. All attempts for a romantic ethics in politics and society, right wing or left would not be successful without realizing and giving importance to these subtle structures and psyche in social realty. Because the black slate impression also served a purpose in survival in the past.

While other political parties may bring divisive forces, which disturb the equality or homogeneous doctrine of democracy, the leftists are not divisive but eternally suspicious of freedom of business, of capitalists, of liberalization and of imaginations of libertines, all putting *a theoretical difficulty* for undisturbed progress of liberty and democracy in present India.

# Chapter 5

*The Indian feels secured in group thinking than in independence of mind.*

## Our Disturbed Rationality

The undifferentiated religion and rationality of Indian mind of Nirad Chaudhury, though is seen now having differentiation, India's transition from a colonial lost mind to a rational mind is yet to be a large phenomenon. Our disturbed progress in rationality is affecting not just science-religion related questions, but all along the day to day arguments on life and questions of righteousness in Indian society. For example, *'I am the cause, I am the effect'* is a popular interpretation to understand the causality in Indian belief. That you are responsible for your problems– the statement very much undermines the role of external world, society and mechanisms, because the spirituality irrespective of its philosophic meaning, has been dominantly transcendental in its practice, to bring an end to the

casual law of cause and effect by individual himself. Such kind of faith and hope I notice along with feelings of helplessness in society and religious approach to existence that questions on the real first cause.

In my 30s I developed interest in astrology, knowing that astrology has no proven theoretical basis, but some statistical accuracy of repetitive results created curiosity in me. I have not exactly recorded the reason of my interest, may be my father had knowledge in astrology or unconsciously I inherited belief in pre-programmed destiny. So I learned the fundamental principles from books by eminent Indian astrologer B.V Raman and then applied to my life and others. But my interest did not sustain long; the curiosity in the subject vanished after a few years because of my social convictions to change human destiny. The life of man is dominantly shaped by society; happenings in one's life are not independent of social systems in which an individual lives; and there is scope to the cross the limits of human difficulties, by brining corresponding social change, mechanisms as proved in history, and so we need not always blame the invisible, unknown fate.

But astrologers do not or rarely give such interpretations. For example if the husband of a lady dies, it has no astrological significance on destiny when society and family give a free, ideological sanction for remarriage and other livelihood securities. And the pre-programmed destiny loses its astrological significance. So also provision of other social security by government

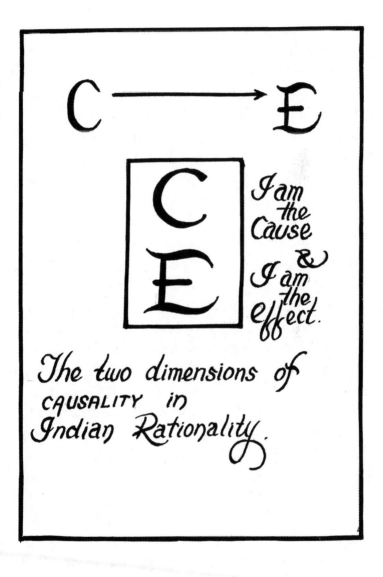

I am the Cause & I am the effect.

The two dimensions of CAUSALITY in Indian Rationality.

that removes economic difficulties. Astrologers instead seem to say that things are possible in mystic ways, irrespective of logicality in social milieu.

Once theft occurred in my house in a rainy night. Indians do not take such happenings only as social phenomenon but as an ominous sign in ones' personal life. And it is also difficult to convince in light of social happenings. When crimes in cities are on rise, it is very mathematical that thieves will try first the deserted houses for greater probability of success. This is to me the right approach to understand crimes and find right solutions. But when we are not confident on social mechanism, we look to divine intervention, fervour for our helplessness and the faith in the unknown becomes stronger. This creates a platitude approach to society, which I have noticed in many wedded to such faiths.

So astrologers suggest mystic mechanisms and then runs the story of immense belief, to adopt the methods by spending money to bring changes in ones' destiny, which defies the common sense rationality of anybody who is well aware of history of religion and rationality in human civilization. The astrological significance had little meaning for me and I preferred to live a life of logic, good sense, determination and faith in social change.

When one believes like this, I have found those people to be compromising more in the name of spirituality; rarely I find them enthusiastic for action and social change. Moving in railway platforms, I find

so many self-help inspirational books, which basically say that our problems are internal and all solutions are also internal. This is self-directed solution of new age that you can be rich, you can create immense wealth, etc exaggerating your confidence and of course inspiring but undermining the significance of society and social mechanisms.

## Enjoying science without a scientific spirit

Modern Indian life is not without rationality, but looking linearly, even though the recent Indian history has passed through 200 year of European values and modernity, Indian renaissance and the beginning of independence with a scientific vision of Nehru, the trend has been very disturbing after independence and Indians continue to be hesitant for a post-theocratic society that may not be always unwise.

Indians enjoy science, then demean it and worship religion and god men. Many even do not hesitate to give remarks on the inability of scientific journey as if the deficiencies are eternal. Remarks like whether science can make dead man alive, can create another universe and so on. Even while giving credit to science in day to day life, some find another important deficiency in science that it is not the location of human values. Does science speak about kindness, love, honesty or the guides of ethical living? No. It can only be found

in religions and their scriptures. So they advocate to depend on religion to stay moral and for guides to life.

There is a big deficiency in respect of scientific spirit and analysing society rationally, though Indians have profusely used the innovations of science and god men sitting in lustrous cars and using all comforts of technology.

See, from morning to night all our requirements, comforts of living, the house, the technology etc. are fulfilled by science.

Then where is the scope of need for religion and its pursuit?

Without explaining satisfactorily, many give the usual statement that in spite of all these claims of science, religion is very important'. They point to the need of values, which in popular perception come from religion.

In this context, most fail to understand that science is not just logical understanding about the material world. It is a logical, systematic way of thinking, of cause and effect, to find out a model that explains happening and helps us to control over the situations. There is no harm if we extend the spirit of logical, rational analysis to understanding of life and society. There is a psychological science to understand the behaviour man, the gamut of emotions, the logical understanding about human nature and difficulties that arises from

violation of those psychic understandings. We all know it in our living and learning process and accordingly behave with each other and for that one need not always refer to what religious scriptures have said. As famous physicist Richard Feynman says, science may not directly speak of values, but certainly helps to guide life. And it does help in deciding right and wrong in many situations.

Even as regards the ultimate location of ethical values that we adopt in society for peaceful existence, we have an erroneous idea that they have come from religion, because retracing our steps, religion originated after origin of man and society. So evolutionary psychologists tell us that even before the origin of religion, when man started society, he must have understood by learning process the qualities, which are required for peaceful coexistence– in essence doing to others what one expects other to do unto one self. And it explains the evolution and refinement of values overtime. Subsequently religion accommodated all the values in its process of evolution through continuous experiments and reforms, and different religions have their special doctrines on living. Even before Hinduism or Christianity came into existence, people lived, had family, mutual existence and that must have been guided by some principles or values to be followed by everyone. In the battles between science and religion, wherever the injunctions of scriptures have failed to solve human problems, man subsequently has resorted

to good sense, reforms, logical understandings and a better religious thinking. The Indian spirit of causality is often idealistic or transcendental, not ready to accept a relationship within the observed, verifiable system of material existence.

*Malika* is an unusual Odiya literature of the 16$^{th}$ century on prophecy written by the mystic and saint Achutananda. The text gives a gloomy forecast on future. Achutananda has predicted the sufferings of good people, the rise of bad people and the end of the earth through a *pralaya* or natural devastation. The Odiya belief in Malika is still in vague like the Indian mind that is very sensitive to fantasy. Extra sensory perception (*atindriya sakt*i) possessed by saints and mystics, is a belief deep seated in the religious psyche. Science and social interpretation, over time, have given jolts to such beliefs and it is possible to imagine about future analysing the present in scientific perspective. Forecasting releases tension, ensures security and the person who does it is hailed as a mystic having extra sensory perception. The constraint that appears while probing mystical issues like tantra, miracle and prophecy relates to the limitations of the methods of determination, but some mindset factor is often visible.

After Odisha super cyclone in 1999, Malika was recalled again in Odiya mind. Music cassettes on Malika were played in public buses. I saw a man from rural Orissa- he was explaining the cyclone in the language of Malika as nature's wrath on urbanites

who are committing sins day and night. The remark is from his unconscious belief in Malika, a dismal attitude towards life apparently and contradictory to the reality that maximum devastation in the cyclone occurred in the rural Odishaa. The basis of many who believe in the statements Malika is the coincidence of happenings- cyclone, devastations and fall of values in society. Some reaction, I noticed, was relishing a pessimistic pleasure in the suffering of fellows. Future for him is gloomy and Malika confirms it– a closing time ahead. To some others, Achutananda as a well-wisher and social reformer has painted a fearful future so that man shall remain god-fearing and not dare to commit sins.

The persons I read have different mental predispositions who perceived the foretelling differently. The same basis when used in reading the life of Achutananda gives some clues. The simple question, why Achutananda wrote on prophecy? Did some supernatural force help him to read the future? Does Malika symbolize sufferings in his personal life in particular and that of society of the 16th century Odisha in general? Instead of mystical considerations, social and psychological explanations have been proved to be more useful for finding clues to human behaviour and such strange phenomenon. Individually, the first part of Achutananda's life till his marriage at a quite matured age in his 40s was difficult. The sufferings he has expressed in poem like:

I suffered a lot in one period of my life

Achuta mohanty my name

or

*Dinakate mora bahu kasana*

*Achuta mohanty mohora name.*

Socially, it was the period of betrays, treachery and internal unrest through which the Gajapati dynasty in Orissa was passing. Persistent attacks from south and of Muslims from north kept people of Kalinga busy in warfare. Culturally, the religious philosophy of Panchasakhas was a movement against the orthodox and oppressive religion monopolized by Brahmis. From the two predisposition: personal and social, it is possible to imagine development of pessimistic thoughts on life, society and future as drawn in Malika. Personal obsessions sometimes coalesce into movements: political, social or literary. The Gita conceptualizes different incarnations of God to clean the evils in society. Jayadev's Geetagovinda depicts ten incarnations of Vishnu– nine have already gone and the last one, Kalki is yet to take place in Kaliyug. It is also possible for a mystical writer to take a cue from such reference in scriptures as corroborative evidences to further strengthen the purpose of Malika.

The post-liberalization rich Indian media has helped to glorify the Indian obsession in mysticism. Though the modern day spirituality is not certainly ascetic, and the Hindu is awake to the shining world, but a desire to escape logic and efforts as an unconscious destined view of life, is also visible. So modern *gurus* are expected to deliver quick results not by taking proactive steps, not by creativity in social mechanisms, but by bringing change in the *ethereal world, through wish-fulfilment mechanisms.* This is surely disturbing the progress of Indians' rational understandings in 21$^{st}$ century.

Some even use science in their personal style, like quoting the philosophic and inconclusive interpretations of quantum physics– as you think so it comes in your life by the mysterious law of attraction. I was appalled to see such interpretation from a guru. Ridiculous and pathetic, it would certainly give a message to innocent listeners that you need not waste energy in social movements, in devising better mechanisms for a better life, like many heroes in history, when you have an easy mechanism of wish fulfilment by the gift of quantum physics!

## *The battle between materialists and idealists*

The battle between mystics and rationalists, between materialists and idealists in India is as old as Indian history. Materialism and materialists of this school explain things within the observed, logically

understood perspective of material existence, giving importance to matter in regulating life even thought process. Idealists have faith in independence of mind irrespective of material existence and explain from philosophical imaginations and self-imposed idealistic aspects. Eminent Indian philosopher Deviprasad Chatopadhya has written significantly on the battle starting from Buddha, Jaina and ending in victory of idealists culminating with Sankaracharya. Ancient India archived all its progress in science, technology, mathematics, literature and secular writings in pre-Sankar period till 7$^{th}$ or 8$^{th}$ century but after the victory of idealists, there was the end of imagination, stagnancy in the progress of knowledge and end of questions and critical thoughts in Indian society. Because it was told that the outward existence and life are illusory and liberation is the only purpose of life, so the phenomenal world need not be given so importance and scriptures (the Vedas) are the authentic source of knowledge that should not be questioned. Though Sankaracharya brought some oneness in different Hindu beliefs and cults, bringing end to superficial conflicts and ritualistic compulsions and said that logical reasoning is an aid to scripture, *he held scripture as the last proof and only means of valid knowledge.* Also he is said to have supported the Brahminical orthodoxy and caste system though he denounced all external appearance as illusory and gave the thesis of one reality. The subsequent period as a consequence moved away from

scientific materialism in thoughts. That the world is made of material elements; even consciousness, feelings are exodus of material body; there is no life after death; enjoyments and sensual pleasure are the only aim of life at the cost of ethical considerations, are some characteristics of ancient *Charvakism* also called Indian materialism, which have appeal in day to day life of people and in fact appear to be the broad tone of modern life character and can be accommodated, except that enjoyment is the only aim of life at the coast of values. The philosophy is said to have been borne as a discontent against the excessive *monkdom* of the Brahman priests, rituals lacking substance, the idealism and abstract of Upanishads unsuited to commoners and the exploitation of masses by rulers and priests, but died in serious thought due to one great demerit i.e. negation of ethical considerations so essential for preservation of life and society.

Another very popular instance of scripture led idealism is the spiritual significance of *Geetagobinda,* a classic 12ᵗʰ century text of songs on Radha-Krishan love composed by Jayadev. The text has profusely inspired art, architecture, philosophy and songs in subsequent times in Indian culture. My understanding of the classic is that as a romantic, ornamental work, it is exquisite. People in their personal life may have a lot to learn from exquisitely creative expressions of love by Radha and Krishna bodily, mentally, in expressions

shedding their ego and surrendering to each other in their solitary pursuit of loyal love.

Second, it may have a spiritual or transcendental purpose as Jayadev has written or as popular interpretations go, like from *deha to deha-tita prema,* but without going into details, a sceptic is inclined to notice some methodological difficulties before accepting the spiritual import. Facts like the self-denial character of the text that it does not mean what it describes as Jayadev has written, need of induction of Radha as a fictional character after two thousand years of mythological Krishna, social-political conditions of 12<sup>th</sup> century India, indications of an effeminate mentality during the time, development of romantic love as an explicit philosophy for union with God, male *bhakti* devotees behaving womanly and the psycho-sexual inner worlds of all these factors influencing the literature, cannot be overlooked in factual-rational perspective. Of course the conditions might have been caused the imagination of this beautiful literature serving a purpose of the time. So if we do not understand from this discerning perspective or refuse to understand so in intellectual ego, in orthodoxy and cultural hype, taking the text totally sacrosanct and beyond criticisms, then it would be to me an act of social irresponsibility; it will not give justice to correct analysis; it will not give correct message to people; it will not correct distortions in peoples' mind on sexual behaviour; and when in recent times, many sexual

scandals of *Babas* behaving in Krishna-gopi style and women falling victims consciously or unconsciously to the appeal of god men for love and divine favours, have been the facts.

The victory of idealists was not a logical victory in philosophic arguments, but the victory of upper castes over lower castes, the later connected with production systems of society. And therefore lower castes were more empirical in their understandings. There was no mobility across caste, no permission for inter-exchange of dialogues and the privileged ruling class for protection of their class interests could dominate others with their idealistic codes of conduct. As former Kerala chief minister and leftist theoretician EMS Namboodripad writes: the exploiting class required and hence produced a theoretical system which could convince the exploited majority that exploitation is the law of god, of scriptural and caste norms. Similar perception is also found in the writings of Yogi Aurobindo on the consequence of defeat of scientific materialism:

'At some time in their history, the absolute, intense aspiration of the Hindus for the beyond, their eternal quest of God, got so one-sided, that they started neglecting matter. India's sages began thus withdrawing more and more in their lofty caves in the Himalayas, her yogis slowly lost track of the physical envelope, this earthly body, which after all holds the soul and is the sacred house where we live and has to be kept clean and healthy and neglected this earth, which gave

us so much beauty and hence has to be preserved and protected as the symbol of gratitude from our soul. And gradually, an immense inertia, a terrible indifference, a great *tamas* overtook India. It is this disinterest to the worldly that permitted the Muslims and British to submit her for centuries. But that it was not always so. The Rishis of the Vedas cared both about the worldly and the other-worldly…'

The victory of idealism is a class dictated victory, and therefore idealism has failed to whitewash the strength of arguments of materialism in day to day problems in modern Indian life that has many such conflicts in trying to identify the moot cause. Iswar Chandra Bidyasagar did not find the mystic doctrines of Ramakrishna Parahamansa useful in solving the social problems of his time. Others in Indian renaissance of 19th century too adopted western enlightenment to analyse society and solve the pressing problems of their time.

But idealism is not completely cruel or voodoo as against belief in some form of independence of mind that I do have. Many great personalities have proved the strength of mind, a moral force irrespective of circumstances in their lives. One day I visited my village and proposed for a library, but noticed the limits of materialism of village people tied to earth and agriculture, who find difficult to imagine on creative transformation of potential, may be due to lack of book enlightenment. So here idealism serves

a purpose of imagination on better ideals of living. Scientist and President Abdul Kalam is no more but has created conditions for the transformation of mind through his inspiring talks and writings. But to extend the transcendental idealism and to impose on the commoners in utter disregard of material aspects, is *a philosophic barbarism.*

Though we all feel that we cannot live without science and logical dialogue in day to day life and as Stephen hawking says, religion is a poor organizer of society and science will beat religion and successful societies will be scientifically advanced societies, the attack of idealism is still on in Indian society. Though caste factor has become weak, new barricades of hierarchy on the basis of profession, income and power relations put significant hurdles in the progress of reasoning in public life. The murder of rationalist Dr Dhabolker in Pune and writer Kalburgi in Bengaluru prove this.

Watching the TV channels on spirituality and mod-day spiritualists, it takes me to a typical rhetoric which they propagate that god and spirituality are the location of all solutions in a simple and direct manner, giving no attention to social mechanisms and compulsions, hardly anybody suggesting for any position of radical action. In Indian mind, God is not only imminent but immanent to human existence as well and this ultimate cause of everything is worshiped for very personal pursuits of mystic pleasure, protection from

a higher force and freedom from limitations of society. In addition to the Hindu view of pre-destined fate and the popular interpretations that god is the doer of everything, our long period of freedom struggle that was a passive resistance has also given a psychological docility. We often feel docile, futility of our actions for class based obstructions to progress of horizontal society; we are not hawkish for social mechanisms, rather posing faith in remote location in unknown fate and the divine controller of destiny.

What is the reason for Indians' disturbed progress in rational thinking? My leftist friend Govinda speaks of the materialistic interpretation– the owner and controller of production system blocks others to think logically by creating barriers, inhibitions and social helplessness, because it helps to exploit others and nurture class interests. While observing resistance to democratic reforms, hierarchy based thinking and treatment towards each other in democracy, I can see the persisting behaviour of people in resisting logical changes, which cut some of their privileges and goes against directly. So my friend's explanation is accommodated within the class interests, the blockades to rationalistic thinking. But then the multiple instruments of democracy also prove to be a blessing in getting justice beyond such class considerations.

Looking to the broad Indian society, I can see also an insisting cultural fixation that comes as a pre-programmed belief in our cause-effect thinking

patterns. After Jawaharlal Nehru who championed scientific temper, our political idols mostly behaved like our general mass instead of becoming role models in leadership. Even our renaissance fathers in Bengal had to refer to scriptures to convince the people about the wrong of such practices like *sati* or against widow marriage that the scriptures do not prescribe so. Our political leaders who are closer to people follow adopting mystic mechanisms like mantra, miracles for respite from difficulties, getting portfolio or winning election. How can then inspire and influence people for the progress of rationalistic thought? The obvious and the most effective reason is that modernity has not penetrated into Indian society because of barriers in good education. My twenty-three years of education put no impact on my mind and personality. It was so mechanical, an unnatural travelling. My real education started after I finished university, by going through classics and philosophical essays and making reflection. And I was propelled to live in certain way and meaningfully. The recent news that none of Indian university is world standard, I do not know why, but basically I feel that we lack fundamental thinking, original ideas and transformative ideas.

With liberalization, high growth rate, food security and the new glamorous identity of India after 1991, today's Indian is not certainly ascetic, not otherworldly, and she does not seem to glorify misery in the name of spirituality and predestined view of life. She does not

tend to negate the existence as unreal because of the confidence given by modernity, science, technological development and social institutions. I also find some modern spiritual gurus interpreting morality and life in a manner with analytical seriousness, not in the traditional abstract way of thinking and presentation. But their trespassing into domains of religious kind of explanation continues to interpret society in transcendence tone and contradictions, like adopting wish mechanisms, quoting quantum physics for life's solutions without corresponding social changes. Another aspect of our disturbed rationality that I am going to tell.

## Scientific perspective of a non-scientist Indian

I have not been a student of science institutionally. Educated in humanities like economics, geography I also read history, psychology and philosophical essays. In my 40s, I fell in love with Physics particularly with quantum physics for my obsession with some difficult questions that I found unsatisfactory to resolve in philosophic imaginations and clever use of words.

The reading of quantum physics was a significant event in my life. It gave me both loneliness and euphoria. Loneliness because retracing steps I saw my origin, origin of man from almost nothing, from the lonely God, felt as if standing on a lonely planet and from there I saw the complexity, the meanings life and

civilisation . Euphoria because it showed me possibilities beyond fixed patterns of thinking, beyond orthodox modernism . In trying to understand the ultimate location of values in human nature, I was caught by a fantasy. I landed in an unimagined place away from social world and in the philosophy of quantum physics. In 2010, I was looking for a scientific basis of ideologies in philosophical conflicts. I have the same feelings of standing on the interface of religion and science, between matter and consciousness, between science and possibility of its ethical interpretation. Man as the centre of societal enterprise, has been perceived differently by different ideologies, so we have varied and often conflicting ideologies. One publisher sent me a new arrival *God is not Dead: What quantum physics tells about our origin and how we should live* written by a nuclear physicist Amit Goswami. More than the title, the subtitle appealed to my curiosity. It is interesting that science is no longer confined to matter and trying to understand the origin of matter and location of consciousness and quantum mechanics is the first step towards this understanding. The wave-particle duality at the sub atomic level that something is matter when observed as matter and also behaves like wave if observed as wave, is not understandable and so it has led many physicists to interpret the nature of existence, and their interpretations basically are opposite of the Newtonian view of universe of fragmented, deterministic, predictable type.

I questioned the diversity, conflicts and tussles in guides to life prescribed in religions; I imagined that a sort of a physics dictated scientific imperialism on values should develop, so that nobody would question it. When Hawking says philosophy is dead, it makes some sense. Philosophy and science have an inverse relationship, and there is little space for philosophical imaginations, inferential and clever use of words in the face of confirmed truth. There would be only one interpretation as science shows, whereas in the absence of confirmed truth, all sorts of philosophizing give scope to religious fancies, and it will continue to remain till man gets a complete understanding of universal existence in matter and other than matter. This is the Grand theory of everything that Physics is searching for. I fancied that scientific basis of values, existence should decide our ethics in family, government and politics and when I came to know that quantum physics makes such interpretations, I emailed a typical question to many physicists like the following:

Traditionally, science is confined to mater and therefore values, ethics are not business of science but of philosophy based on our varied understanding of human nature and problems. But when physics has put steps ahead of matter to understand the origin of matter and location of consciousness, what quantum physics indicates about the ultimate nature of existence and ethical principles if any from that to follow in life? Because in one sense values, human nature and ethics

must also be part of those laws of universal existence of which human life is a part.

In reply to my email question, Fritz Schafer an eminent quantum chemist of USA sent me the book *Science and Christianity: Conflict or Coherence* written by him, which is a very pleasant debate on science and religion and the views of famous scientists both theist and atheist. Religious minded views the universe to have a meaning and some characteristics in nature are imagined as characteristics of God like caring, powerful, harmony, beauty and there are similar statements in different religions.

Physicist Fred Wolf in reply to my question wrote:

'I wish I could tell you that science did offer proof of ethical values or their lack thereof, but it simply doesn't. Scientists are no more ethical or non-ethical than priests, bankers, presidents, or garbage collectors. What quantum physics has shown me is that we have the power to change how we behave in any circumstance; we are not machines; we are not robots. With this power I find hope in life and in how we can behave towards ourselves and to others.'

Though quantum mechanics is more than hundred years old, its philosophical implications as regards the ultimate nature of existence are still debated and not accepted unanimously. But as an innocent reader I was initially swayed by the interpretations that are opposite

of Newtonian view of life. Like Frifjof Capra of 'Tao of Physics' and Amit Goswami indicating the parallels between quantum physics and spiritual philosophy of the east and that the contemporary society, economy, organizations, thoughts are not in harmony with the fundamental characteristics of consciousness, not reflecting the correct interrelatedness, and the unitary nature of universe, which is basically spiritual. They speak of an interconnected universe and the derived spiritual nature of life, and that our patterns of living should conform to the essential nature of consciousness, but then there are also criticisms supporting the fragmented reality, instead of the unitary concept. This single theory of everything is taken by some physicists and philosophers to be the ultimate cause of human conflicts and sufferings in contemporary world. So much so it amounts to say that spirituality and god are proved and so also the existence of consciousness as quantum collapse of particle into thought waves.

Post-modernism thought in social world is a new development. It is a metaphor of the quantum physics interpretation of physical world that there are no universal truths and ideologies, but one as one views. There is no authority, no book to decide what is right and wrong and everybody is right in his own way. So it encourages new imaginations beyond conventional wisdom and beliefs. Some interpretations like the interrelated nature of society, human feelings appealed to me as practical tips for the contemporary economic

crisis, international relations between countries. So this is basically a world view adopting a deep consciousness approach to every issue of life. Though the quantum view of existence is a metaphor for the social world, but some have started interpreting that perhaps laws of physical world and laws of human nature have a single location, may be with some different patterns as Stephen Hawking indicates in his book *Grand Design*. To me Physics does indicate something about *values* to follow, because human nature that fundamentally decides the values to adopt in life, is not beyond human biology like we all feel pain, pleasure and hunger, and its biology is not independent but a part of universal laws of physics. So some emotional character seems to be embedded in the universe.

Later serious readings of essays of Fritz Schafer, Stephen hawking, Richard Feynman, Victor Stinger shook my innocent belief even from a common sense perception. That these are only interpretations having missing links, not conclusive proofs and it is not logical to jump to unnecessary characteristics and conclusions. This is not the death of deterministic belief, predictability and certainty; the universe is neither good nor bad and we have to decide our values. The unitary approach is not correct, we live in a fragmented world that makes analysis possible, and conscious makes collapse is an unfortunate use of word by Edward Schrodinger.

Opposite view of quantum physics is the Newtonian world that became a dogma in western view of life in 17th century and ruled for 300 years and still is the dominant culture of the west, though it is not the whole truth and its statements as regards behaviour of matter at sub-atomic level have been falsified by discoveries in Quantum physics in 20th century. And the message of Newtonian view was carried to all segments of life. Psychology, Allopathic medicine, Economics were modelled in material line of science.

I have enjoyed reading of *Grand Design* by Stephen Hawking, whom I consider to be a determined physicist who is free from impressions of faith and traditions in human thought, who prefers to interpret on evidences or possible evidences unlike others for whom faith and god naturally come as a clue to interpretations. Also in India, I see many scientific minded laterally plunge into beliefs on seeing slightest coincidences with scriptures like in Upanishads as if there is no need for further explorations; everything in detail has been explained on why god created, how he created and what is the mechanism. Answering on what was the need of God to create life, they say it would give scope to humans to fulfil their desires. But where from first human came and why? While psychological significance in *Upanishads* like let all be happy, let noble thoughts come, some other doctrines on mind study and life I have to appreciate, the metaphysical approach to life and universe I am not inclined to believe so literally.

I even being not a student of science do not appreciate it from a logical and honest perspective. One may interpret the hazy ideas, the smoke, in scientific explorations, but all these interpretations continue to remain as interpretations only, not conclusive statements like many interpretations of quantum physics. Some call it *mystic physics* therefore. This is not research nor this way the mystery will be unfolded in its mechanisms. While Hawking gives opinion that god may exist as quantum vacuum as the first cause, he splits the definition and characteristics of god to say that his interference as the doer of everything is not necessary in the creation process of universe that inflates from quantum vacuum to maintain energy balance and it is the automatic physics of universe. It may not be correct but this helps in systematic and analytical advancement of thought.

But then speaking liberally and sympathetically when we do not have a complete understanding of universal existence and life is not completely predictable, some such mystic faiths may be *an insurance against limitations* of science and society in solution of problems and Indians adopt this for the same reason. May be alright if the belief is safe, not insane.

I should have read physics. It appears to me the distant location of all knowledge from quantum world perspective, and this is reason of my love in the subject. And I look forward to a time when physics would locate the values and philosophy of living bringing

the gap between science and religion to zero. Where is the location of left and right of ideologies in the universe? And the whole of political philosophies that must respect human nature and the mathematics of mutual existence and it would be scientific to the extent of reduction of conflicts in social existence.

But Indians indulging, taking pride in westernisation of life comforts, which is a gift of science, do not seem appreciate widely the logical relations, an order in scientific thought. Rather many of our understandings about life and society continue to be scriptural, obsessive and we fail to apply the logic well in case of society.

## *In managing the society rationally*

Our family lived for a long time in Puri for my father's posting there as an executive magistrate. I read in local college till my graduation, and I used to visit the famous Jagannath temple. My wandering, observing mind still preserves the impression of management style followed in the temple; a practice of hundreds years of excellence, the way priests manage the temple affairs is effortless, smooth, hardly without any flaws and with beauty; they work with devotion, pleasure, team spirit and well-ordered planning. Casualties were rare and the temple administration on the part of government did not much interfere in the way.

I am referring to a philosophy in the traditional art of management followed in Indian culture. This is

the spiritual type, a behaviour if not always followed, is well noticed and well understood in India. *An interconnectedness, less hierarchy, diffused ego, beauty and emotions, resolving in mind than in matter, focus on meaning and spirit rather than on formalities, holism instead of superficial fragmentation are noticed to be the language of traditional patterns of Indian management.* This also I have noticed in secular organizations wherever managed spiritually like an old hotel in Puri. The owner seems to be spiritual in behaviour and well respected, and the hotel has flooding customers. People are attracted to the hotel for moderate price, quality, cleanliness and good behaviour. I have taken food several times in the hotel and experienced good feelings, watching the management there.

After independence, Indian society had a great task in nation building, and it has got magnificent achievements in different fields from agriculture to space, but the process has not been a pleasant or easy experience for problems in mindset, not always for problems in its capability. Understanding the management culture in modern Indian society is not independent of Indian mind in post-colonial times; *the management culture noticed around is neither spiritual nor so scientific but continues to remain lost and split in psyche.* So I had to retrace my steps on time and recondition my personality. To understand what management should be like, I started reading scientific theories of management like the books *Excellence in*

*Management, Great ideas in Management by* Parkinson and Rustomji, *Administrative behaviour* and the Indian spiritual type like *Management with a difference* written by D.P Gupta of Pondicherry.

As an officer in government, I sometimes involved myself with emotions and broader life of my office staff, maintaining my position and extending beyond official relationships. I never perceive working life to be different from larger life rather see it as continuity, subduing my ego and impressions of history. There was a staff in my office who had a habit of irritations and impatience. It was on flimsy grounds and frequent. Others staffs even avoided talking to him unless it was so necessary. Even when I asked, he lacked patience in giving detailed replies. I found it very indecent. The usual approach followed is by snubbing the person with warnings, because it protects the ego of the authority. But I had patience and I wanted a real change in the person. So I made personal interactions with some details of his problems; it was a sort of psychoanalysis, and I gave some tips how to reduce irritation. It gave him a sense of satisfaction that the authority is trying to give some special care to understand him, rather helping to improve on behaviour. In a training institute my small, innovative step was appreciated that I have taken steps to improve management in my office and inspire others in government. I continue to pursue my morally compelling obsession and a position of praxis that I have taken for management innovation in

government and for significant achievements in times ahead.

Office management rules I followed but with meaningful interpretations, because rules mathematically are not full proof to exhaust the human behaviour and needs. It has been rather more rewarding in psychological management of staff than in punishments. Minor conflicts, clash of ego among staff I have diffused by calling everybody to open dialogue, logical understanding and through inspirations. This gave tremendous freedom to my staff in doing their work smoothly; and it improved their play of mind, giving some meaning and psychological comfort in work place. This too gives me some moral strength. Subsequently after many years, I felt that lower level employees often lack a managerial sense of doing their works, of dealing with others in office for which I faced difficulties in day to day affairs. So I wrote a leaflet on *Basic Managerial Principles* and circulated among staff and motivated to feel and follow. This has also been a good experience. Then I wrote and printed a booklet titled *Managerial skills for Government Officers* containing leadership management, time management, self management, health management, task management and circulated copies among officers.

This has been my story of management philosophy in working in office. It was a sort of discovery of larger life in work place that I always wanted to make; it has been very much my attitude of getting wedded to larger

radius of my existence; and I felt myself to be more scientific, out of lost self and impressions of history. I realised Peter Drucker that management is truly very much a human discipline over many other material aspects. With guidance, inspiration and helping to solve issues, the system moves without much watching.

Management is beauty. It is a beauty because it brings out the harmony. The organization of Jogi Aurobindo in Pondicherry instantly creates such feelings. A deeper consciousness approach. They call it depth psychology, which science does not understand much because it is not the commonly experienced human nature. But there I had flashes of some special feelings. Oceanic like and so free! Ego there is not a concentrated point in space and time; it is identified with each and every body. A discovery of life beyond normal feelings and possible patterns beyond individualized existence in workplace is what I observed and experienced. All may not feel easily tuned to a spiritual level of consciousness, but the pursuits of deep meaning, purpose and harmony there very much create nice, peaceful feelings and flashes of better patters of life– a possibility beyond the everyday language of body and mind.

Modern management philosophy over the years has drifted from a mechanical cruel type to deeply human and consciousness approach. As a spiritual approach, management of the self is the precondition for managing the outside world. The wise Indian philosophy says, before you create order in external

world, first see the order within, make a review of the self and reflect on the condition in which you are and your mental health. D.P. Gupta's *Management with a difference,* published by Aurobindo society, is a small book hardly 70 pages. It gives an insight into review of management philosophy and the art of mind conditioning for managers. The exact method that he gives is to analyse the external information in a state of mental detachment from the external world, in a quite mind where distracting emotions are not there, in a calm body and with a mood to make journey into the internal world within– things become clearer in this state of mind and the manger becomes able to make a better processing of the information just as the clear water reflects the sunrays, which muddy water cannot. It is not always by brain storming and externalization of senses of the western analytical method that knowledge is gained, but a complementary calm brain helps in taking a better vision of problems, better decisions and better course of actions. As Dr Gupta says, the conscious and discriminating self within called *vivek* is the best consultant within the individual and all external information should be pushed to this chamber for better processing and correct judgment. But then if the manager, the administrator, the person refuses to be spiritual, what next? No way to ensure, but resort to mechanisms, laws, codes of conduct etc. like in modern times.

Indian leaders, intellectuals in pre-independence times were haters of the British rule, not so of British civilization. Rather many had inferiority in Indian identity as Nirad says, Nehru was a perfect British and did not prefer to induct in important posts who was not educated abroad. But missing the cultural roots, many of our understandings in modern organisations and management are not original. Too fragmented and reductionist; alien to the cultural roots and useful collective unconscious of history, it neglects the Indian mind and the denigration of own culture has been the painful effect for our anglicized servitude and Indian inferiority complex. Where the terrain is a desert, bushes become only thorny. A lost mind who cannot see himself fails to perceive what harmony looks like. The style of management in current Indian society is still having obsessive fixations from history; their appearance, their language, their moods owe very much to the recent history. It surprises me that though management philosophy in the last many years has advanced to a very democratic and scientific level, for our hierarchical character and acedia, many organizations probably have not come this realization.

Coming to the leadership aspect which is as important for any organisation, or as Napoleon said, there were never bad solders, only bad officers, Indian executives rarely inspire and or have the emotional inclination to spread currents of encouragement and vision among functionaries. What the white revolution

man Kurien or metro man Sreedharan have been able to do in their fields writing highly inspiring stories of achievement, motivational leadership is not mostly noticed. Many passionately follow the style to sustain power relations than product relations. The colonial hangover is still on and as a mark of psychological compensation, command style of leadership in managing the affairs in society is still projected as glamorous and prestigious. The result is percolate hypocrisy, inefficiency along with achievements that one notices in different spheres in society.

Relationship management deals with managing relations between authority and employees in work place. Philosophy of relationship management over the years has drifted from materialistic approach to more and more of behavioural, human touch in work place –like the 'Theory X' that workers are basically lazy and have tendency to slack off and therefore by force and punishment, they can be made to work and productivity can be increased whereas the 'Theory Y' says that given importance to the emotional state, workers, if given a supportive work environment, get self-motivated. The philosophy of management now gives central importance to man. This is for the simple but fundamental reason that everything is done through 'MAN'; he is viewed as the whole of management; and therefore his development, his concern, his peculiarities should be given principle attention.

So the democratic and psychologically appropriate definition is that a manager is most effective if he considers his main function as that of helping his subordinates to do their job, is yet to be felt in governance. This is as experts say 'Management by Walking Around'. To understand the problem of workers on the spot, the authority, should put his legs in other man's shoes; he should leave the chair, make free interaction and analyse the situation from the perspective of the individual and then from organizational point. Prakas Mishra who was the police chief of Odisha was a highly motivating, inspiring officer well visible in his personality; he successfully curbed Naxal activities in the state; and who remained present on the spot during major operations. He is now CRPF chief.

As a family tradition, Sudhir Kakar says that the Indian executives are poor in team work for psychological distance from the father and family hierarchical tradition of obliging to older figures. And he cannot say anything to females for his intimate obligation to the mother. So the executive fails to create a logical work culture. We look each other in inferiority often habitually because we accepted not our superiority but superiority of British. We see our lost-self in each other. So oozing power, he often looks to the other in inferiority. And as Nirad concluded, Indian executives for the same hierarchical nature are servile before superiors and arrogant before subordinates. This has

been a clear, dominant characteristic I can confidently say from my experiences.

Management is a buzz word after economic liberalization where the private corporate has certainly shown the beauty in management at least in service delivery to customers, to the onlooker in decoration of things, of efficiency, interior beauty in corporate office corridors, in shopping malls. Like the Phoenix mall in Bangalore, a heaven height of fantasy, of beauty, imaginations and cleanliness in face of hundreds of shoppers coming and going. This proves ascent of managerial sense of the nation in corporate affairs, bringing some positive impressions on mindset, professionalism, managerial efficiency in government.

## *Between internal tuning & social mechanisms*

Spirituality has been the twin-sister of religion. It attempts to have a separate identity as alternative to religion, as a belief system of secularists and rationalists, rejecting the conflicts and prescriptions associated with different religions but believes in some deep intuitive perceptions on existence and life. Some call it depth psychology. But as the twin sister if often risks into religion and talks in religious terms that I have found in so called spiritualists. A feeling of infinitude in transcendental world, that an evolution of individual is possible, a progressive experiences in transcendence in which the objective world becomes more and

more insignificant; and individual assuming growing independence is an Indian conviction in mysticism.

'I am a different person than what I am in all other times; I am located outside of normal domain of my personality; a cool shower of pleasure on my head; I am feeling happy for no such reason in the external world; and I do not so feel the everyday instincts of my body and mind'. Such spells of transcendence have occurred several times in my life. I had been to Pondicherry in 2011 and I was deeply impacted. An infinitude. So free! Growing in power; things coming to my control; a longing for everybody; and accepting people in their own dispositions. But very consciously I could see that the feelings were not because of the spiritual ambience or legacy of Jogi Aurobindo alone, rather in European style of clean, dust free roads, artistic impressions and a socially peaceful ambience oozing some specific feelings. Transcendental wisdom there has not neglected the need of beauty and harmony in the external world of matter, in human existence; the feelings are not very much an independent existence, but from *the specific arrangements of material beauty,* which spirituality often neglects in Indian life.

Feelings of transcendence create some independence of mind. In my experience it is not just some feelings of crossing limits or some goodness called divinity. Going further, it unlocks an individual locked in body, in mind, in society, in history, in situations, giving courage to defy the normal patterns of mind that I have

felt very much. The flashes of abstract order on issues in my mind, which are not ordinarily visible, rather fuggy in my conscious intellectual exercises, become clear in moments of transcendence. A platform where standing as a witness, one looks to his life and finds a scope to cross the instincts of mind and body into unbounded terrain! It changes the pattern of my living; an efflorescence of creativity enriching life without loss to others, a win and win situation. Ever since I am experimenting at times in such psychological set up, given my good theoretical understandings on spirituality.

But the feelings of transcendence are not repetitive or predictable like any scientific experiment. Spirituality is not as scientific as any law of science and such feelings do not last long or appear as and when desired. Science does not have a model to explain it, but it does not mean a hidden model is not there in nature. No serious thinker today believes that spirituality is voodoo even if the literal location of its existence, the soul, is not known. No serious minded would like to overlook the rich data on such feelings, in true spirit of psychological inquiry. There is one high profile philosophic explanation from quantum physics for such experiences that thoughts make collapse creating similar experiences and flashes of intuition through circularity, reducing gap between cause and effect, between subject and object. Some call it quantum consciousness that can cross the location

in mind. But all these are still debated scientifically. A mysterious terrain!

In reply to my question on interpretation of quantum physics and why one should be spiritual and what it indicates on spiritual nature of universe, physicist Fred Alan Wolf replied,

'There is no scientific evidence for ethics. There are opinions of some scientists of how one should behave ethically based on their own idiosyncratic beliefs. I include myself in this list. Why should you behave spiritually? I really can't tell you, no one can. You are not a machine. You can behave as you like. However we do have laws and we all know from them what constitutes ethical behaviour...'

While accepting for the moment that spirituality is the last effective way to solution of human problems, if this is not the way then no other way as Aurbindo philosophy says, it is puzzling to see that spirituality is not a naturally found phenomenon; world is not instantly spiritual rather very much guided by mind and bodily impulses and by some good sense of course and one has to go through a process and develop an agenda for spiritual transformation of personality. In spite of rich culture available on morality, if the world does not voluntarily adopt godliness in behaviour, there is no way than to enforce righteousness through mechanisms.

The rationalists feel shy of uttering spirituality for the fear of being levelled as religious and superstitious;

they talk of values instead; and to justify it one may say that when logical values have been enforced through social mechanisms, there is no need of spirituality that involves the risk of talking in religious terms. Here is the need why I feel to go beyond values for better protection of value itself. Values require legal mechanisms for their enforcement; and individual selfishness has been checked through such laws. But individual has also defied mechanisms however just, for either he cannot accept it as a matter of philosophy or has been guided by impulsive instincts, greed and violence. There have been suffocations, failure of mechanisms and feelings of its limitations, as experienced in modern times, whereas good minds hardly need such regulations as we all feel intimately. Spirituality here is the intuitive respite that indicates a scope for psychological transformation of individual on his own accord, a self-regulation without going through complicated mechanisms of society. As Jogi Krishnananda says, accepting the futility of pride in external mechanisms is the beginning of true wisdom within. This is the light of spirituality, which shows the sure way in a simple manner.

India has a rich reservoir of such subtle culture; this is our spiritual capital, very alive against satires and aberrations associated with it at different times. The economic philosophy of life as followed in the west has been followed in India as a historical legacy. We inherited a ruined economy, so initially focus on growth and generation of material value in the production

process was all right, but in recent times the growth obsessed minds in addition to fulfilling our needs, are also creating tensions in our mutual economic existence. We have a rich legacy of methods of spiritual living like Patanjali speaking of *asteya* and *aparigraha* meaning abstinence from greed and non-covetousness for others' property that is unlawful and unethical, which may be inspiring for a peaceful collective existence. Physicist-philosopher Amit Goswami says that the future road map is consciousness economics, which recognizes the spiritual urge as a human nature and by investing in more and more production of such spiritual living patterns, man develops a desire for containment, positive manifestation of creativity, instead of becoming obsessive for growth, for greed and covetousness. As he says:

'So much energy was generated in the subtle domains in the Indian culture that even today when there is real poverty in the material domain, the Indian poor is not always unhappy, because they continue to inherit and maintain their subtle wealth. If Karl Marx had seen that, it might make him rethink whether the exploited classes are always unhappy!'

For example, there was a man who carried cooking gas cylinder to my house in his cycle from the supplier. I noticed him very happy looking. When I inquired a little, he told me that he read regularly the *Bhagabat purana*, a poetic manifestation of Indian philosophy that is supposed to give him the pleasure of divine honey.

I cannot overlook the primacy of his internal happiness for manifestation of outwardly happiness, the subtle energy that keeps him buoyant; *and such behaviour is profusely noticed and well understood in India, if not always followed*. I find the behaviour not always mystic, but like any other psychological feelings. Feelings of interconnectedness in relationships, resolving in mind than in matter, feelings of complacency even with moderate livings, focus on meaning and spirit than structural formality even while following modern patterns are there and easily recalled in Indian collective unconscious.

When I was writing this book, *Kumbha mela* was running in Allahabad. *Kumbha* is the great Indian festival of romance in mysticism and gathering of mystics from all parts of country. It is a large showcase of the Indian obsession for fulfilment of deep desires of soul, in transcendent to the most time reality of mind and body. It seems to say, 'I am on the way to a very personal aspiration, into a limitless experience and please do not bind me always with finitudes of society, body and mind'. My neighbour, who attended the mela, narrated to me his ecstasy of forgetting family. During the time, India had some tension in the border– two Indian soldiers were beheaded by Pakistani army. But the Indian attention is always divided between society and absorption in other worldly pleasure. The Indian may not be as materialistic as western type but he may be selfish, preoccupied in himself for the personal

transcendental evolution and progressive freedom from material existence. *That is why freedom is very much appreciated, even from the clutches of society.* The aspiration of renunciation of an Indian jogi may not have much to do with the material world but he is selfish in another way– seeking God and liberation of the self.

Through evolution of self and corresponding spiritual revolution in external world– this is the Aurovindo ashram and the Aurovelli city in Pondicherry making an experiment in spiritual living and spiritual economics. Accepting wealth collectively as in nature, with moderate individualism, the person is groomed for internal tuning, for possible emergence of feelings of beauty, of infinitude, of fulfilment in an environment of deep understanding of nature not only scientifically but intuitively as well. All may not be prepared for such a life, who would prefer the conventional modern living for fulfilling the potential within. I too see hope in Narayan Murthy of Infosys who says that in ultimate analysis we are all temporary custodians of wealth and it would be our wise responsibility to give it to lees fortunate and miserable. The Indian psyche carries age old convictions on anxiety of human existence; and it may continue to remain as a mystical land on internal pursuits in life. Spiritual transcendence may be useful as a personal pursuit of realising the deep questions inside but it sings dull in reducing the anxiety of social existence, so long as our spirituality feels tired of social

thinking and interprets society mystically and so long we make the society messy and then run away for peace. While I experience transcendence, I also feel disturbed by the conflicting language of both the terrains!

The famous *Totapuri sadhu* of a high mystic order who lived in Puri in 1960s and who is said to be the spiritual master of Ramakrishna Paramahansa and to have lived for about two hundred years, once scolded an engineer devotee who constructed a road to his ashram. Because it disturbed his peace. *The order and romanticism in the external world may become insignificant in transcendental happiness, which the western world probably overlooks in their interpretations of Indian righteousness.*

જી ભ્ડ

*The author*

$\mathcal{T}$his is his first ambitious literary work. He has an impulsiveness to theorize the large radius of worldly existence. The personal introduction and first chapter in the book about life in Indianness in his 30s and 40s speak on his impulsiveness of writing the present work. He uses a method of literary appeal with theoretical rigor of difficult social issues in a manner accessible to general readers. Having interest in political economy, history, psychology, and interpretations of science, Amulya Mohanty professionally works in the field of development planning. He lives in Bhubaneswar, India.